MFA
HIGHLIGHTS arts of africa

mfa
BOSTON *MFA Publications* Museum of Fine Arts, Boston

HIGHLIGHTS arts of africa

Kathryn Wysocki Gunsch

MFA PUBLICATIONS
Museum of Fine Arts, Boston
465 Huntington Avenue
Boston, Massachusetts 02115
www.mfa.org/publications

© 2019 by Museum of Fine Arts, Boston
ISBN 978-0-87846-864-5
Library of Congress Control Number: 2019937257

The Museum of Fine Arts, Boston, is a nonprofit insti-
tution devoted to the promotion and appreciation of
the creative arts. The Museum endeavors to respect
the copyrights of all authors and creators in a manner
consistent with its nonprofit educational mission. If you
feel any material has been included in this publication
improperly, please contact the Department of Rights
and Licensing at 617 267 9300, or by mail at the above
address.

While the objects in this publication necessarily rep-
resent only a small portion of the MFA's holdings, the
Museum is proud to be a leader within the American
museum community in sharing the objects in its col-
lection via its website. Currently, information about
approximately 400,000 objects is available to the public
worldwide. To learn more about the MFA's collections,
including provenance, publication, and exhibition his-
tory, kindly visit www.mfa.org/collections.

For a complete listing of MFA publications, please con-
tact the publisher at the above address, or call 617 369
3438.

All illustrations in this book were photographed by the
Imaging Studios, Museum of Fine Arts, Boston, except
where otherwise noted.

Edited by Jodi Simpson
Production editing by Hope Stockton
Proofread by Nancy Sullivan
Typeset by Fran Presti-Fazio
Design and production by Christopher DiPietro and
Terry McAweeney
Series design by Lucinda Hitchcock
Production assistance by Jessica Altholz Eber
Printed and bound at Verona Libri, Verona, Italy

Distributed in the United States of America and Canada
by ARTBOOK | D.A.P.
75 Broad Street, Suite 630
New York, New York 10004
www.artbook.com

Distributed outside the United States of America and
Canada by
Thames & Hudson, Ltd.
181A High Holborn
London WC1V 7QX
www.thamesandhudson.com

FIRST EDITION
Printed and bound in Italy
This book was printed on acid-free paper.

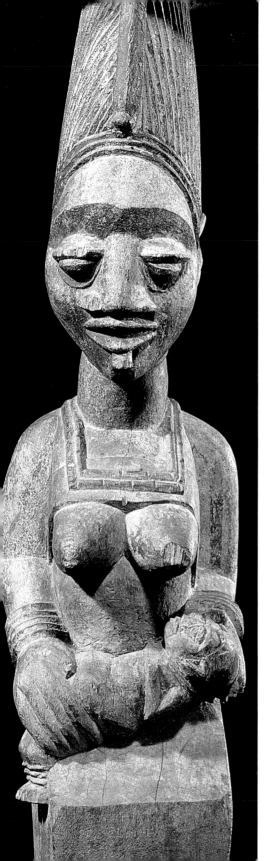

Contents

Director's Foreword

The collections of the Museum of Fine Arts, Boston, bring a multitude of ideas about the human experience under one roof and witness the ways in which people across the globe have approached everything from fashion and trade to faith and politics. The African collection, which encompasses artworks from the sixteenth century to the present, is one of the newest additions to the MFA. Founded in 1991 through the generosity of William and Bertha Teel, collectors and educational publishers who wished to share their passion for African and Oceanic art with the wider public, the collection has grown to more than 750 objects. Bequests from the collection of Genevieve McMillan and the world-class gift of Benin kingdom sculpture from Robert Owen Lehman, as well as gifts of individual objects from a number of generous supporters, have helped the MFA to build destination-worthy galleries. Recent additions have expanded the narrative beyond West and Central African art dating to the period of colonial occupation (roughly 1880–1960) to include the voices of contemporary artists as well as masterpieces from one of the continent's most celebrated royal traditions.

Through collaboration with African Diaspora communities in Boston, the artworks illustrated in this book are joined by interpretation and programming in the galleries that reflect diverse viewpoints on the meaning of each artwork and the history of its journey from the artist's studio to a new land. By sharing highlights from the African art collection in this volume, we hope readers will be able to dive into selected stories in the art, history, and politics of a continent that is home to more than a billion people.

Matthew Teitelbaum
Ann and Graham Gund Director
Museum of Fine Arts, Boston

Acknowledgments

This book began to take shape in 2015, after a year of getting to know the collection and the people who formed and sustained it. It is a snapshot in time of one of the MFA's newest collections; a future edition would undoubtedly have even greater treasures to share. No project is ever completed alone, and I want to thank the many people who have helped this book become a reality. Chris Geary, the Teel Senior Curator of African and Oceanic Art Emerita, kept meticulous records of the collection and her research on it, which made this book far easier to write. Chris and my colleagues Darcy Kuronen, Department Head and Pappalardo Curator of Musical Instruments, Pam Parmal, Chair and David and Roberta Logie Curator of Textile and Fashion Arts, Kristen Gresh, Estrellita and Yousuf Karsh Senior Curator of Photographs, and Laura Weinstein, Ananda Coomaraswamy Curator of South Asian and Islamic Art, each let me adapt entries from their recent publications for selected artworks, and I am grateful for their extraordinary knowledge of postcards, musical instruments, textiles, photography, and Islamic art, respectively. Provenance research underlies much of the research used in this book, and Monica S. Sadler Curator for Provenance Torie Reed's tireless efforts and ingenious methods of finding new information on the collection is an incredible asset to my work, and to our ability to be transparent about the difficult histories of many African artworks.

Colleagues outside the building also improved this work. Cindy Kang, one of my dearest friends from graduate school and now Associate Curator at the Barnes Foundation, read the introduction for tone and balance. Nichole Bridges, a valued colleague and Associate Curator for African Art at the St. Louis Art Museum, helped to restructure the introduction to make it more helpful to the reader. Rebecca Brown, Professor and Director of Graduate Studies at Johns Hopkins University and a friend I miss from my Baltimore days, gave thoughts on framing as well. Together, these three friends got the book off to the right start and I appreciate the time they took to help. My husband, Nate, has infinite patience for dinner-time talk about my work, and his indulgence as I worked to refine this project made it stronger.

Special thanks to Theophilus Umogbai, Curator at the National Museum in Benin City, and Dr. Endy Ezeluomba, Françoise Billion Richardson Curator of African Art at the New Orleans Museum of Art, for helping with the difficult-to-track-down Edo language terms for Benin artworks. I would also like to thank the many colleagues, too numerous to name individually, whose research is reflected—though at times dimly—in this text. All mistakes and infelicities in this volume are, of course, my own.

My small department works well only because of incredible support. Kelsey Mallet, my fabulously competent former Department Coordinator, helped keep other projects moving while I wrote the text. Haley Carey, who ably assumed the Department Coordinator role last year, is a constant source of calm and encouragement as I have worked to complete the book. Katherine Mitchell, department intern, read through a late draft and pointed out text that would be unclear to readers unfamiliar with African art. The wonderfully organized Katie Olson created the tombstones and combed department files for information at the start, leaving an easier-to-use archive in her wake.

The publications office at the MFA has undergone many changes over the years, but each person I've worked with has been supportive and encouraging. Emiko Usui, now at the National Gallery, gave this book the green light and we all still miss her here. Anna Barnet, now studying at University College London, gave gentle criticisms that made the text sharper and easier to read. Hope Stockton has gone through images and text and taken edits with a sense of good humor and collegiality—I hope we will have many more projects together. Jodi Simpson edited the entire book during a period of great difficulty in her family, and her grace and professionalism under pressure was nothing short of inspiring.

The MFA's African collection would not exist without the generosity of Bill and Bertha Teel, Ginou McMillan, and Robert Owen Lehman. Bill and Bertha, whom I regret never having had the opportunity to meet, have friends at the MFA still. I delight in hearing about their love for art and passion for life, and I am grateful each day for their commitment to sharing African and Oceanic art with a broader public. Ginou McMillan allowed the MFA first choice of objects from her vast collection at her passing, and the highlights of her home are treasured here. Robert Owen Lehman changed the face of the MFA collection when he generously donated 32 artworks from Benin and 2 from Sierra Leone. The world-class sixteenth-century bronze sculptures and reliefs and the ivory saltcellars stun visitors each day. As a Benin scholar, I am particularly thankful to see these masterpieces in company with our visitors and the Boston-based Benin diaspora.

Other generous donors have added key pieces to our collection. Carolyn and Eli Newberger have shared the joy of art collected in Burkina Faso in the 1960s

over the course of many years. Lou Wells has given two celebrated Liberian masks to the collection, too late to be included in this volume but no less admired and appreciated. Helen Braider entrusted to us a sculpture purchased by her grandfather in Sierra Leone in 1895, giving a beautiful work that also has important historical data. Margaret Wells generously gave us the last figural Liberian robe in private hands, allowing audiences to appreciate the finest work and latest fashion of northern Liberia in the early 1900s. Deb Glasser is a constant support, generous donor, and good friend. I am grateful to her for her gifts to the department, including the show-stopping eagle coffin by Paa Joe, but treasure our adventures together even more.

Gifts of art made the collection, but those who help build an audience expand its impact. We are all grateful to Dr. Arese Carrington, who visited the late Oba Erediauwa to discuss the Lehman gift of Benin art to the Museum. Thanks to Dr. Carrington, the MFA is the only Museum to have the palace's blessing for displaying Benin art and working with the local diaspora from the kingdom. The work of Alex Omoregie, Anne Osula, Osazee Woghiren, Henry Idada and other members of the Coalition of Committed Benin Community Organizations have made the galleries more accessible and have shared the Benin community's knowledge with visitors to the Museum. I am grateful for their friendship and look forward to our future projects together. Over the years, the Africans in Boston group, Afrimerican Culture Initiative, and the Nigerian American Multi-Services Association have made special events at the MFA a part of their annual programming. I have enjoyed getting to know the leadership of these volunteer organizations and am inspired by their passion for keeping African art and knowledge at the forefront. The Curator's Circle, a successor to our long-running Friends group, has provided funding and encouragement for all my efforts here. I appreciate the work of our steering committee—Deb Glasser, Rodger Dashow, Bob Freeman, Eric Fortess, Peri Onipede, Lou Wells—to expand this group and make it possible to improve our presentation of African art through loans.

This book is dedicated to the memory of Bill and Bertha Teel, who formed the collection and endowed a position to care for it. I am sure they knew what it meant for the MFA—and for Boston—to finally add African and Oceanic art to our encyclopedic collections. They began the work of integrating diverse global narratives into our building and our city, work that will continue for years to come.

Kathryn Wysocki Gunsch, PhD
Department Head and Teel Curator of African and Oceanic Art

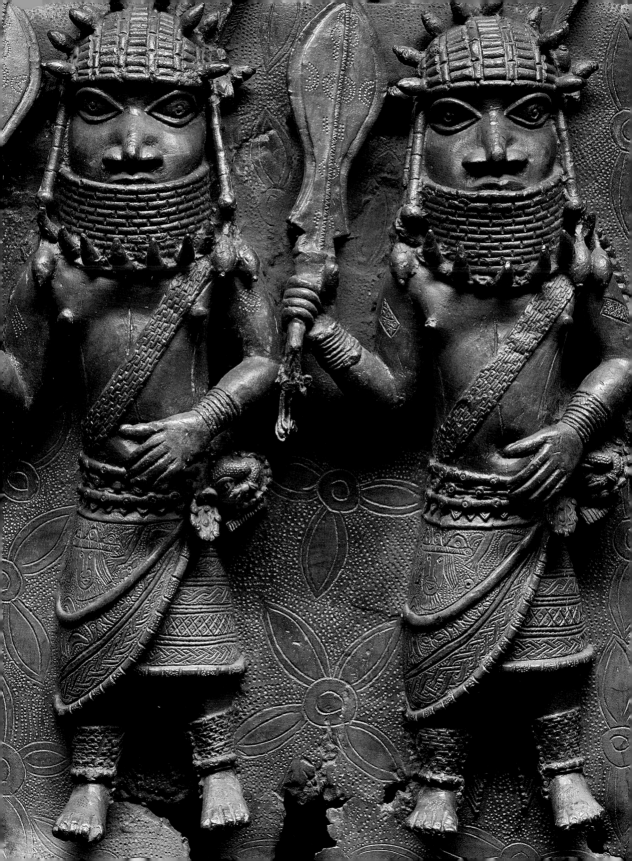

African Art: Then and Now

Dressed in finery and holding swords aloft, the men depicted on this bronze relief plaque demand attention (fig. 1). The artist has recorded every detail of their intricate ensembles, including the beaded coral net crowns that end at the brow-line and accentuate the men's open gazes and abstracted, deep-set eyes. Beaded strands fall from these crowns to the men's shoulders, framing elaborate coral-beaded collars that cover their lower lips. Strands of coral cross the men's torsos, while coral bands encircle their wrists and ankles. Two layers of finely woven cloth and embroidered belts wrap around the men's waists; the faces woven into the pattern on the upper skirt represent the Portuguese people and suggest access to imported luxuries. Leopard-tooth necklaces, leopard hip-ornaments that hide the knot securing their waist wrappers, special swords used for dancing at court, and the profusion of coral regalia all signal that these men are elite courtiers serving the king, or oba, of Benin. The oba is metaphorically praised as a leopard, an animal that is swift, smart, and powerful, while the coral represents the oba's great wealth. This small relief panel, with its world of detail, is part of a much larger commission of more than 850 plaques that once hung in shining magnificence in the audience court of the king of Benin. The story of this object—how it was made, collected, and studied—reflects not only the history of the kingdom of Benin, but also the larger history of African art in Europe and America, and provides an entry point to explore the collection of African art at the Museum of Fine Arts, Boston.

The kingdom of Benin, located in what is today Nigeria, included more than two million inhabitants at the height of its power in the sixteenth century, stretching over an area roughly the size of New England. The art, fashion, and political organization of the court inspired its neighbors, influencing many smaller societies in the region. The oba controlled militias feared for their military prowess. Benin's expanding territory brought wealth through tribute payments and the adroit management of trade and markets. The kingdom's internal political struggles led to decreasing regional power in the eighteenth and nine-

fig. 1. Detail of a relief plaque showing two officials with raised swords, by the Benin Royal Bronze Guild, Benin Kingdom, Nigeria, c. 1530–1570

teenth centuries. In 1897, the British military invaded Benin City and occupied the palace. The British claimed political dominion over the kingdom, joining it to the Nigerian Protectorate, a colony where citizens had few political rights and local leaders lost their sovereignty.

Benin artworks entered the market during this period of political and economic turmoil. This plaque was sold by the British state, which had seized many artworks during the war with Benin; others were sold by soldiers who had taken them without official sanction. Art was also sold within the Nigerian Protectorate by people—both local and foreign—with access to the palace and its stores. European and American museums and private collectors bought these artworks. The art of Benin was particularly prized because it was made in bronze and ivory and had a naturalistic style. These features made it easy for Europeans and Americans to recognize Benin reliefs and sculptures as artworks, because the pieces fit into their existing definitions of art. But this plaque didn't fit into nineteenth-century European and American estimations of African ability. When Benin bronzes first entered the international art market, some scholars argued that they could not have been made by artists from Benin, because they were too technically advanced—statements that reflect the deep racial prejudice of the period. Over the following decades, scholars studied Benin bronzes as if they were from a distant planet, cataloguing the kinds of animals and plants in the artworks or the shapes of bodies, for example, rather than simply asking Benin courtiers art-historical questions about who commissioned these artworks, where they were originally displayed, and why they were made. At this time, scholars routinely discounted the Benin court's knowledge about patronage, iconography, and history.

The story of this Benin artwork illustrates how the beginning of African art study in Europe and America continues to affect the way African art is understood today. In the nineteenth and early twentieth centuries, an academic focus on Africa through the lenses of ethnology, botany, and zoology supported false colonial narratives that claimed Africans were incapable of self-rule; these political claims eclipsed the serious study of African contributions to philosophy, religion, and art. In the Americas, the enslavement of Africans continues to cast a long shadow of racism and institutional bias, its ramifications in scholarship and museums still unfolding more than a hundred and fifty years after the formal abolition of the terrible trade in human lives. For many visitors, it is impossible to see African art today without considering the devastating legacy of colonialism.

The relationship between Africa and Europe originated in an era of mutual benefit and respect through Mediterranean trade in the first millennium BC.

Trade continued across the Sahara in the Middle Ages and expanded along the West African coast during the European age of exploration, which began in the fifteenth century. Such trade was profitable to rulers on the continent and abroad, and included ivory, palm oil, copper, pepper, rubber, and other commodities. Most notoriously, this trade also included enslaved people from conquered territories, which created wealth for local rulers and their trading partners but devastated parts of the continent and millions of human lives. The trading outposts that European countries had established along the African coast in the fifteenth and sixteenth centuries formed a base for a military and political occupation beginning in the early nineteenth century. By the mid-nineteenth century, European merchants were no longer willing to pay the African middlemen who gathered inland goods to trade with their international clients on the coast. As a result, these merchants demanded military assistance from their respective governments in order to move farther inland, where they could buy directly from palm oil and rubber collectors or hunters with access to ivory.

What began as a trade war became a war outright. European militaries subjugated local governments that refused to agree to commercial arrangements that preferentially benefitted European merchants. Soon European powers were not only fighting local governments, but also vying with each other for control of territories with a wealth of raw material. In 1885, these European countries negotiated among themselves in Berlin to divide up spheres of influence on the continent, claiming the land and its produce without consulting reigning local sovereigns or their subjects. From 1885 on, the colonial powers coerced local rulers to cooperate with their authority or fought to establish control of contested territory. Once their authority was established, colonial governments built railroads and river portages in order to facilitate the movement of goods to the coast. These market improvements benefitted European businesses but were paid for by local people through newly introduced systems of taxation and forced labor, a particularly punitive form of government taxation akin to slavery.

In this period of political and social upheaval, colonists were convinced that African societal structures would cease to exist. Some colonial officials felt that the supposedly superior example of European religion, political thought, and culture would convince Africans to abandon their own beliefs. Other officials worried that the disruption caused by forced labor would erode local cultures beyond repair, as healthy working-age men were forced to leave their homes for long stretches, creating a power vacuum in local leadership. Missionaries, anthropologists, and colonial officers collected evidence of the ways of life of the people around them, sometimes motivated by a genuine desire to understand local culture, and at other times to document cultures they considered doomed to extinction.

Many colonial and missionary objects were sent to ethnographic museums, which were newly formed institutions in the 1870s. These museums assembled material in order to study various human cultural systems. Ethnographers and their supporters collected and purchased a wide array of objects for their museums—from fishing hooks and twine to artworks made for royal courts. At the time, politicians, businessmen, and the academic community welcomed the foundation of new ethnographic museums in their cities, because such museums signaled a commitment to cutting-edge science and research. This broad-based community support ensured that many ethnographic museums, particularly in Germany and the United States, had the resources to purchase tens of thousands of objects each year. The market for African objects began at that moment, when dealers—both African and European—sourced artworks and other objects for sale to museum staff and ethnography enthusiasts. Some pieces were claimed by colonial militaries from newly conquered peoples and sold to fund further wars of colonial expansion. Other artworks were traded when their owners converted to a new religion and no longer wished to own instruments of their former faith. Still others were abandoned to decay, often considered a respectful way to discard an object too worn or broken for further use. Enterprising local or international dealers then collected these discarded pieces and sold them abroad. Some African artists began producing pieces explicitly for the foreign market, a new source of patronage during terrible times. Due to the lucrative new European market, unscrupulous colonial officials in this era at times used their political authority to seize artworks or coerce families into selling them—a history of the African art market that has been long acknowledged in scholarly journals but has only recently become part of common discourse, due in part to the criticism of this history articulated in the 2018 blockbuster film *Black Panther*.

At the turn of the twentieth century, a second market for African objects emerged that acknowledged their status as artworks. Henri Matisse, Pablo Picasso, André Derain, and other artists living in Paris in 1907 began to appreciate the new-to-them forms of African, Oceanic, Native American, and ancient South American artworks. Their passion for the sculptural traditions of the world outside Europe spread to other members of avant-garde art circles. Paul Guillaume and Charles Ratton, two dealers working in Paris at the time, promoted African art to a wider public. By the 1920s, fashionable French homes often included a Dan mask or a Baule spirit spouse, representatives of two sculptural traditions from Côte d'Ivoire, which was at that time under French occupation. From this moment on, art dealers in Paris, Brussels, London, and New York worked to promote and sell African art as art. European dealers purchased artworks in the major colonial cities, including Abidjan, Kinshasa, and Lagos,

from African dealers whose names were rarely recorded. These African dealers often had a network of buyers scouting smaller towns and villages for artworks.

Some African and European dealers also set up workshops to create the kind of sculptures that collectors in Europe preferred. European collectors felt that pieces made by such workshops were derivative, and therefore deemed them inauthentic, or fakes, as opposed to original artworks. Ever since, collectors of African artworks have prized objects that show signs of use by a local owner or audience, which is considered proof that the artwork was acceptable to a local patron and is thus "authentic." Collectors' preferences have affected the artworks at the MFA as well. At different times in the life of the object, an art dealer or owner might have added or removed clothing and jewelry, deliberately cleaned and polished its surface, or applied dirt or oil to give an impression of age and frequent use. Conservators carefully examine sculptures to determine whether the surface was created by a dealer or is a result of the object's original function, and attempt to restore the original appearance when possible.

Most of the African objects at the MFA date to the period between the 1870s and the 1960s, the period of the colonial occupation of the entire continent, except for Ethiopia and Liberia. Like other European and American collections, the MFA collection includes primarily West and Central African art. The colonial officials and missionaries—largely from France, Britain, Germany, Belgium, and Portugal—who initially collected African art as souvenirs or to sell to museums appreciated the wooden masks and sculptures they encountered in these regions as art. The sweet expression and gently swaying body of a sculpture from Sierra Leone read immediately as art; a stunning embroidered tunic from Liberia, however, did not fit European definitions of fine art at the time. For Europeans of the late nineteenth and twentieth century, textiles, pottery, and basketry— all highlights of East and Southern African traditions—were considered to be utilitarian crafts or ritual paraphernalia, worthy of study from the perspective of anthropology or botany, but not as artworks. MFA curators have been working to fill this gap in collecting through purchases of contemporary and mid-twentieth-century textiles and fiber arts. No museum can build a fully comprehensive African art collection, however. Body painting and murals, part of traditions across the continent, are by their nature difficult or impossible to collect. Other artistic traditions are missing due to the art-historical perspectives of early European collectors. For example, the calligraphy, metalwork, and ceramics of the Islamic cultures of North Africa are rarely found in African galleries despite their geographical origins; ancient Egyptian collections were likewise excluded from African art galleries, a decision that seems strange today. Early scholars argued that Egypt was most connected to the ancient Mediterranean cultures of

Rome and Greece, ignoring Egypt's geographic location and intimate trade and political links with the kingdom of Nubia further south on the Nile. As a result, museums today present a smaller perspective on the art of the continent than might be expected from a collection called "African."

In 1970, William Teel, who would go on to donate the core of the African collection at the Museum of Fine Arts, Boston, published the first commercial series of slides and illustrations to introduce American university students to African art. He included objects found primarily in museums, as well as examples from major private collections. More than 90 percent of the illustrated artworks were made in West or Central Africa, with nearly half from territories that now comprise Nigeria and the Democratic Republic of the Congo. Teel's collection founded the MFA's African art department, and the emphasis on Nigerian and Congolese art is clearly visible. This book reflects the MFA collection's emphasis on West and Central African art, but it also includes a small sample of the African artworks from the Islamic North African and contemporary collections in order to highlight the work of artists across the continent and across time, even though those artworks are not on view in the "African" gallery. Ancient African art is featured in our *Arts of Ancient Egypt* publication.

Today Africa is home to 1.2 billion people, more than one thousand languages, and a great diversity of spiritual and artistic practices. The art traditions of West and Central Africa represented here encompass an area roughly the size of the entire United States inhabited by more than five hundred million people speaking more than six hundred distinct languages. The artworks date from the sixteenth century and include traditions as diverse as bronze and ivory sculptures from the kingdom of Benin, funerary art from Gabon, court arts of Yoruba and Bamileke kings, abstract religious sculpture from Mali, and elements of performance art from Sierra Leone to the Democratic Republic of the Congo. Some aesthetic preferences are shared in many (but not all) societies across this broad geographical area, and influence artists further north, east, and south. West and Central African art traditions often reflect an interest in representations of the human body. As a general rule, figures are sculpted in full, with the entire body presented. Bust-length portraits are uncommon, although some sculptures of heads only, without the shoulders, are known in different commemorative traditions, including the kingdom of Benin. A beautiful bronze casting from Benin captures the smooth, full cheeks of a man with an elaborate crown and coral necklaces framing his face (see p. 41, right). In many artworks, particularly in Nigeria, the head is proportionally larger in the composition than it is in life. The head is seen as the seat of destiny and wisdom, and as the most important part of the body its proportions are exaggerated. As in the Benin commemorative head,

the faces of African sculptures are often fully adult but not aged. Artists tend to portray men and women in the prime of life, widely defined as the late twenties or early thirties, when a person has acquired a level of dignity and knowledge but retains the physical vigor and fertility of youth. The artist's emphasis on the musculature of the body is part of the preference for youthful idealization, as in, for instance, the powerful body of a mother on a Sango staff (see p. 94). In many artworks, as in this one, the figure's stance enhances the impression of youthful strength. Figures are frequently sculpted with their knees and arms flexed, as if ready to act.

A sculpture's sex is identifiable through physical traits more than through the style of the artwork. Women's bodies usually reflect their life-giving role. Sculptures of women often depict the breasts high and full, like a nursing mother's. Artists who have carved women with flattened breasts are working from the same theme, as this detail of physiognomy emphasizes that a woman has already served her family and community by giving life to many children. Sexual organs are nearly always indicated on sculptures, but they would not have been visible in the objects' original context. Nearly all African sculptures were dressed by their owners with clothing and jewelry—one sculpture had a skirt when it was photographed at the British Museum in 1920 (fig. 2). Sculptures were only dis-

fig. 2. Late 19th-century female figure from the Democratic Republic of the Congo shown with waist wrapper as it appeared at the British Museum in 1920

fig. 3. The same female figure seen without waist wrapper as now displayed in the British Museum

Wooden figure, Baluba people. S.E. Central Africa. (British Museum)

played without clothing when the objects entered European collections, a common story repeated for this figure, who today retains an ear ornament but has lost the fiber skirt that once afforded her some privacy (fig. 3). European collectors preferred to see the sculptures unadorned to admire *body*, whereas African audiences appreciated a dressed, and thus more civilized and more complete, representation of a *person*. European collectors in this period often divided art forms taxonomically, but for many African patrons, the multimedia presentation of a sculpture with textiles and jewelry fit within a broader art culture that valued different art forms working together simultaneously, such as masquerade performances where music, dance, sculpture, and fiber arts joined together into a unified experience.

Many African artworks have a religious function. As elsewhere in the world, art in Africa is made to enhance the pleasure of this life and to offer a conduit to the powers of the next. Men and women pray for help and guidance, asking the spiritual world to maintain children's health and families' safety, ensure that work is prosperous, and keep enemies at bay. Although religious beliefs vary greatly across West and Central Africa, there are some common elements of faith practice. Many societies demonstrate continued remembrance of an ancestor by caring for sculptures and reliquaries. These objects either honor the deceased or provide a means of communication with the departed by acting as a place to direct prayer. Caretakers might caress the sculptures so often that they are worn smooth. Likewise, they might anoint sculptures with oil, as one might care for the skin of a beloved child or an elderly relative. Sculptures might be offered wine, gin, or a bit of a nice meal as a way of sharing these daily pleasures with the deceased. A detailed Fon altar depicts the deceased enjoying such a meal— its once-bright paint, still visible on the flags, has been dulled because of the many offerings the family has left for the spirit of their loved one (see p. 58). On special occasions or to make a serious request of the deceased, a supplicant might sacrifice a chicken or other small animal. This altar shows a goat and a chicken flanking the seated figure, referring to this practice.

Artworks used in a religious context may or may not be sacred themselves. Certain sculptures are intended as sacred homes for spirits invited to enter into communication with people looking for guidance or help. Other sculptures are purely ornamental reflections of more sacred objects or ideas, such as the figures that adorn collections of relics or those that serve as memorials to the deceased; these objects are not in and of themselves powerful or sacred, yet they are treated with respect.

Like sculptures, masks vary greatly in their form and function. Men's associations in West and Central Africa often commissioned masks to perform during

annual post-harvest thanksgiving celebrations, funerals, and communal gradu-
ation ceremonies. Some of these masks are considered as sacred as an altar,
while others were made for a single performance and have no greater meaning
than a prop in a play. The *minganji* masks illustrated below, for example, are
neither sacred nor permanent—they are made for use during a single initiation
cycle, as their perishable materials (bark cloth and twine) make clear (fig. 4).
Boys ready to become men first wrestled the mask away from their slightly older

fig. 4. *Minganji*
masqueraders,
photographed by Eliot
Elisofon, near
Gungu, Congo in 1970

peers, and then were allowed to wear the mask to hide throughout town and sur-
prise their mothers and girls their own age. After the end of the initiation period,
the mask could be thrown away, or sold. Still other masks are commissioned
by performance groups to entertain a crowd and earn money from spectators
during the holidays. The young men who commission these masks prize novelty,
seeking to wow a crowd, and so such entertainment masks feature great variety
and give an artist room to innovate. Regardless of whether they are sacred or
secular, all masks are part of a larger aesthetic ensemble of music and dancing.
The way masks are worn is as varied as their subject matter and performance
context: they can be placed fully over the head like a helmet or on top of the head
like a baseball cap, or they can be worn balanced above the head or in front of the
face. The way the mask is worn is usually tied to the dancer's movements. Helmet
masks and heavy masks worn in front of the face make breathing too difficult for
aerobic choreography, for example.

Nearly all sculptors in West and Central Africa during the late nineteenth and early twentieth century were male and created artworks for their immediate community and the surrounding area. Outside of royal courts, most of these artists had a primary job. Artists may have been farmers who had free time for creative pursuits during the dry season, when cultivation wasn't possible. Many were blacksmiths, who sculpted or carved in breaks between clients. Pottery was typically a women's art. Weavers may have been male or female: different communities throughout the region treated this art form as either men's or women's work, or a combination of both. In all media, a few artists rose to such renown that they could live entirely on fees for their work, but this was as unusual in West and Central Africa as it was elsewhere.

Artists working in West and Central Africa have as many different forms of training, payment, and motivation as there are patrons. An artist working for a king, for example, is likely to have apprenticed with a master artist or guild for a period of many years before working on his own commissions. Obembe Alaye (about 1869–1939), who sculpted two columns as part of a series to ornament a memorial altar in the courtyard of the King of Efon-Alaye, in Nigeria, trained and worked in a city with multiple master carvers competing for commissions and training new generations of artists (fig. 5). Most art made for non-royal patrons, however, is created by artists who have devised their own training. These artists have learned from talented people in their area, and some may even have entered a formal apprenticeship. It is more common, however, for such artists to develop their own talent through practice, client feedback, and watching other artists at work whenever possible. Once a person displays a facility for sculpture, for example, he might make sculptures for neighbors between his other duties. The criticism of his work could help the artist improve his compositions and technical skills; if he continues to improve, a regional reputation could bring enough income to make it a worthwhile professional pursuit.

In the past, artists were paid in kind—it was common for an artist to receive prepared food during the creation of the sculpture, and a gift of chickens or gin as a final payment. Today, most aspiring artists train in universities or art schools, and are paid in cash when a gallery sells their work. These artists are not as limited in choosing a medium as artists in earlier generations were. In rural communities, however, some part-time artists are more likely to follow gender norms in choosing to carve, sculpt in clay, or weave. These artists, who create masks and sculpture for traditions that are constantly being reinterpreted and updated to remain relevant today, often agree to work for a combination of cash and in-kind payments, preserving some traditional payment methods that honor

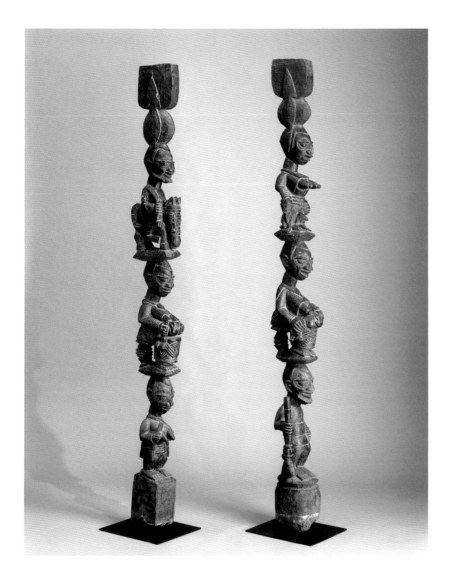

fig. 5. **Two palace posts,**
by Obembe Alaye, about
1880–1930

the artist, such as providing food while the artist is working on a piece. As in the past, these artists are generally self-taught or learn through apprenticeship.

The majority of artworks in this book are wood sculptures. Although West and Central Africa are now mostly savannas due to overexploitation of timber resources in the past—a problem that continues today—wood was more plentiful in the nineteenth century and earlier due to lower population and trade pressures on forests. Artists chose particular species of tree with great care. Lightweight bombax wood is used for Sande society masks, for example, because

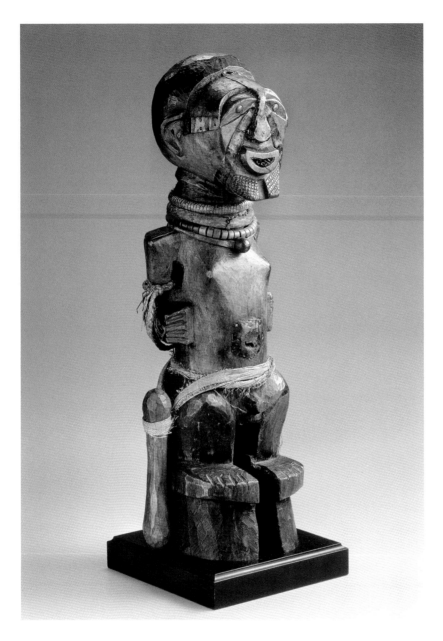

fig. 6. **Power figure** (*nkishi*),
Songye region, southeastern
Democratic Republic of the
Congo, 20th century

these masks are designed for women to wear with ease. The iroko tree, a tropical
hardwood, was used for the pillars that supported the roof in Yoruba and Edo
palace courtyards, an art commission that also served a critical architectural
function. For certain sculptures, artists may carve newly cut wood because it is
easier to work. In other traditions, artists cure the wood by leaving it in the sun
for a number of years, so that, once carved, the resulting sculpture will not crack.

The fact that many African sculptures are made of wood is not in and of itself a sign that they weren't intended to last. Wood in the dry deserts of Mali can last centuries, and the MFA is home to a wooden sculpture from Egypt that dates to 2300 BC. In more humid climates, wooden artworks are sometimes stored in rafters over a cooking fire to keep termites and dry rot away. However, some sculptures were intended to have a relatively short life span. Sculptures that are made for the spiritual purposes of their original patron are not usually passed down to the next generation, because they have accrued a spiritual power that can only be properly cared for by the original owner. This *nkishi* figure, with its compact pose and its direct, open face, for example, was likely sold after its original owner passed away (fig. 6). Family members, particularly those who were members of Christian churches, may have been reluctant to keep these sculptures around, either because of a belief that owning such objects was blasphemous or because they were nervous about the power of the spirit that at times inhabited the sculpture and were unsure how to appease it. For different reasons, old masks—particularly those used for entertainment—are also rarely treasured over many generations in most traditions. Masks are continually renewed with fresh paint or accessories before each performance, and new masks are introduced frequently, so older masks can become obsolete.

The age of an artwork is not as important as its ability to serve its intended purpose, whether spiritual or secular. A broken mask or commemorative sculpture is more likely to be replaced than restored once it is beyond the point of looking perfect, whereas a sculpture that is designed for a spirit may be repaired if it remains an effective conduit for prayer. In the broadest terms, African patrons express a preference for pieces in excellent condition, as a sign of either newness or careful storage and preservation. Completeness and the attractive appearance of a new or renewed surface are important aesthetic factors for artworks intended for use in performance or for display, while the efficacy of the object is of primary consideration for devotional arts.

Aside from wood sculpture, cotton and indigo-dyed fiber arts are also part of African artistic practice. Cotton and indigo were major exports to other continents for centuries. Cotton was cultivated in North Africa for millennia, and Saharan traders brought the techniques of raising cotton to West Africa, where it became an important crop by the eleventh century. Loom technology was also borrowed from these nomadic traders, and the narrow-framed loom continues to be used in major West African weaving centers today. Master weavers like Samuel Kofi, who works in the celebrated *kente*-producing center of Kumasi, Ghana, will weave a narrow strip up to 200 feet (60 meters) long with a pattern counted out so that the strip can be cut and joined edge to edge to create com-

plex ornamentation on the finished cloth. This technique has survived because it allows the weaver to add a second series of warp (horizontal) threads to a cloth. The second warp is visible only on one side, creating a unique, two-sided surface that isn't reproducible on mechanical looms.

Indigo dyeing is an ancient technique on the continent as well. Until the introduction of chemical blue dyes in the late nineteenth century, indigo was a major source of wealth, both as a cash crop and through the dyeing industry. In Kano, a Hausa city in northern Nigeria, indigo dye vats are still in use today for luxury textiles. Yoruba communities in southern Nigeria and the Dioula merchants who spread throughout West Africa from Mali were also known for their skill in indigo dyeing, which requires precise control of the temperature, stirring, and alkalinity of the dye bath. The trade in enslaved persons from West Africa to the Caribbean and the United States brought these techniques to the new world, where their forced labor made it possible to grow indigo as a cash crop.

Lesser-known plant fibers are the basis for celebrated weaving traditions in some parts of the continent. The Kuba kingdom, in what is now the Democratic Republic of the Congo, has been famous for its raffia velvet since the fifteenth century. Raffia velvet is made by pulling apart palm leaves to draw out fibers 35–60 inches (90–150 centimeters) long. These are then dried and woven into cloth, which is further embellished with palm fiber embroidery, cut pile, or, from the nineteenth century onwards, pulled and drawn work techniques introduced by Belgian missionaries. Among the Dida of Côte d'Ivoire, this raffia fiber is braided instead of woven on a loom, and then tie-dyed to create rectangular patterns. Dida cloths have always been a luxury item, due to the incredible investment in time and skill required to create them (see p. 83). Bark cloth, in contrast, is a more accessible plant fiber because it requires less labor. Families in regions that used bark cloth for clothing, including areas in what is now the Democratic Republic of the Congo, planted particular species of fig, often *Ficus natalensis*, for their bark. A certain layer of bark could be harvested from the trees, beaten to soften the fiber, and sewn into larger cloths. The smooth, soft textile made from this method is naturally white, but could be dyed as well.

Imported fibers have been a part of international trade for centuries too. North African traders brought wool and cotton to the continent in the tenth century, and by the advent of the maritime trade with Europe, novel textiles were in high demand. Wool, linen, and silk were particularly sought after. Local wild silk, which is a fine gray, was appreciated in certain traditions across the continent, but imported white silk, which was easier to dye, was more popular. African dyers have locally available sources for blue, yellow, green, brown, black, and purplish pink, but no true red dye. Red is an important color in many

traditions throughout the continent, and so red imported cloth has always found a ready market. Since the nineteenth century, newly invented fabrics, including rayon, polyester, Lurex, and other synthetics have entered the scene. Printed "African wax" fabric, first made by the Dutch for an Indonesian market, became fashionable in West Africa in the early nineteenth century and is now made on the continent and in Asia as well, creating a truly global market. Cotton prints—and ready-made clothing—are less labor-intensive than *kente* cloths or other hand-woven materials, and are therefore much cheaper. Many people now wear hand-made clothing connected to historical traditions only for weddings and funerals, and not as everyday wear, due to the price and quality of these items. As a result of the decreased demand, fewer people train to become weavers and dyers, and the industry largely serves a wealthy clientele.

In addition to wood sculpture and fiber arts, bronze-casting has a long history on the continent. Most bronze artworks are made using the lost-wax technique. An artist creates the desired form in wax, carefully covers the wax form in layers of clay, and bakes the clay so that the wax is liquefied and drains out. The artist pours molten bronze into this clay mold and when the bronze has cooled breaks it open to reveal the completed artwork. Because the mold is broken, each bronze piece is unique. In European traditions, lost-wax casting is used to make the rough form of an object, and artists then complete the piece by chasing—that is, using a chisel to carve and shape the metal. In most African traditions, the artist works to create even the finest details in the wax model. West African artists had access to a natural latex that was ideal for this kind of work, holding finer details than are readily achieved in wax. Artists then used very fine clay for the first layers to cover the wax model, so that the casting would retain the tiny details of the work. After casting, the artist would fix minor imperfections, but there was no need to chase the casting.

In the Benin kingdom, the making of bronze, an alloy of copper and other metals, relies on imported materials. While there are copper deposits on the continent, they are rare, and so copper has been part of regional and international trade since ancient times. From the fifteenth to nineteenth centuries, Benin kings commissioned some of the most spectacular royal monuments on the continent. Although art made of wood may or may not be intended to last, in the Benin context in particular, the choice of material does have a direct bearing on the artwork's intended lifespan. The verb *sa-e-y-ama* in Edo, the language of the Benin court, means both "to cast a motif in bronze" and "to remember." Bronze is therefore a perfect choice for memorial altars or royal commissions commemorating major events (fig. 7).

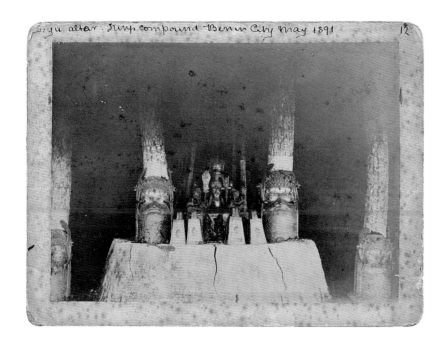

fig. 7. Ancestral shrine in the Royal Palace, Benin City, photographed by Cyril Punch in 1891

In contrast to imported bronze, ivory was plentiful and commonly available until the twentieth century, when the cumulative effects of international demand led to the endangerment of elephants. Small-scale ivory jewelry or amulets were objects that even middle-class people could afford. African artists have also made finely worked ivory souvenirs. A saltcellar, likely commissioned by a Portuguese merchant, combines imagery common on the Guinea coast with that drawn from European woodcuts or playing cards (see p. 115). Given that ivory has always been a sought-after material, however, kings and other rulers generally controlled this lucrative trade for export, and large-scale use of ivory is more often a sign of luxury arts than art for common people. The MFA collection lacks examples of the large ivory sculptures that were common in the Benin kingdom, where carved tusks were placed on top of the commemorative bronze sculptures on royal memorial altars. Instead, a delicate Benin hip ornament depicting the Queen Mother gives testament to the skills of the royal ivory-carvers guild (see p. 38).

The African art collection begun at the MFA in the 1990s is a small portal into the life and politics of a large and complex continent. Through these artworks, which illuminate the history of different societies and periods, this book offers an introduction to some traditions within the wider field of African art. Each chapter presents artworks through the framework of their original contexts: in palaces, in sacred places, in the streets, or in the global art market.

By examining the places where these objects were first encountered by view-ers—the palaces of Mangbetu kings, the busy streets of Lagos, or a gallery in London—more vivid stories emerge about who made, paid for, and enjoyed these artworks. The sheer size of the African continent, home to humankind since its very beginning, is hard to imagine, and the wealth of its history and culture, shaped in part by artists and their patrons, is almost impossible to grasp, but the following pages provide a tantalizing glimpse.

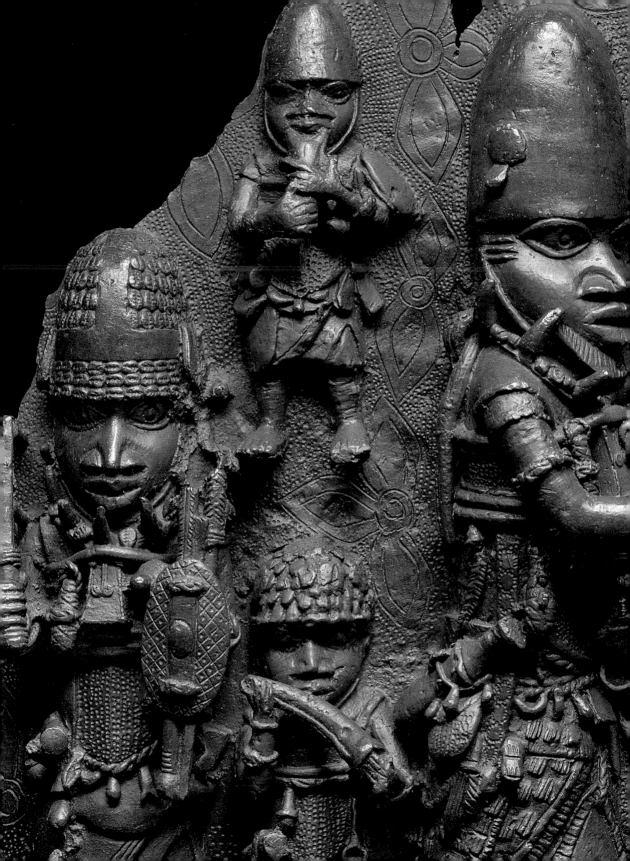

Art of the Palace

With the wealth of an entire territory at hand, kings lived in grandly proportioned palaces covered in sculpture and filled with locally crafted and imported luxuries, and commissioned art on a lavish scale that instantly communicated their power to subjects and visitors alike. These artworks augmented the reputations of rulers controlling the worldly and spiritual fortunes of their subjects. Kings provide a link between this world and the spiritual realm, with the king's physical body a metaphor for the body politic; the king's well-being therefore ensures prosperity and peace for his people. Imagery of strong men and fecund women likewise underscores the connection between the health of the nation and a king's wisdom, piety, and success.

The objects featured here range from ornaments worn by individual leaders and courtiers, to shrine objects intended to honor royal ancestors and invite their intercession in the fate of a kingdom, to architectural sculptures used in internal and external diplomacy. These individual works are small excerpts from larger royal narratives and only a taste of the wealth of each court. The largest group of objects comes from Benin, providing a glimpse of one of the world's oldest surviving kingdoms. The current king of Benin, Oba Ewuare II (r. 2016–), traces his lineage through two dynasties to the foundation of the kingdom in Benin City, around the year 900. In the late fifteenth century, Oba Ozolua expanded the Benin kingdom into an empire stretching from the river Niger to the western border of modern Nigeria. This territory, around the size of New England, included more than two million subjects. Through tribute payments from conquered territories and taxes on trade, Ozolua's son and successor Esigie had the means to commission monumental art for the palace. A highly active patron of the arts, Esigie projected a new and more powerful image of the oba of Benin after a period of dynastic struggle and an attack from a neighboring kingdom. Much of the MFA's collection of Benin art dates from this period of great wealth, rapid expansion, political turmoil, and deft diplomacy.

The MFA collection also includes masterful sculpture from the early-twentieth-century palaces of Yoruba kings in Nigeria, and from the grand homes of the chiefs of the Cameroon Grasslands from the same period. The Yoruba palace pillars and the Grasslands portrait sculpture both portray mothers, a nod to women's role in continuing a royal line, as well as a metaphor for the fertility of a king's subjects and their lands. Elements of court regalia from the Kuba kingdom in the Democratic Republic of the Congo provide a more intimate glimpse of court life. The sumptuously worked velvets and appliqué panels were worn by men and women of leisure in the capital of the Kuba kingdom as a sign of the taste and erudition of the assembly.

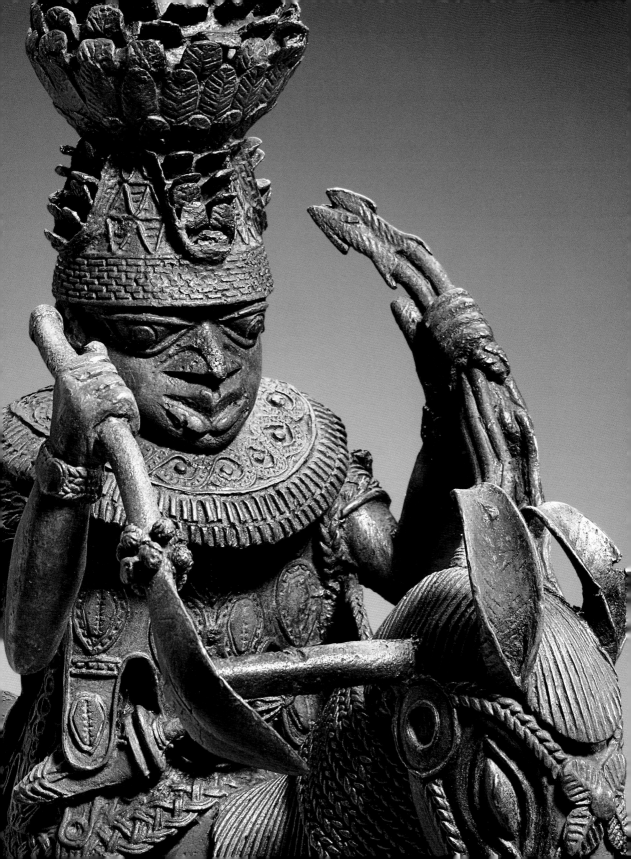

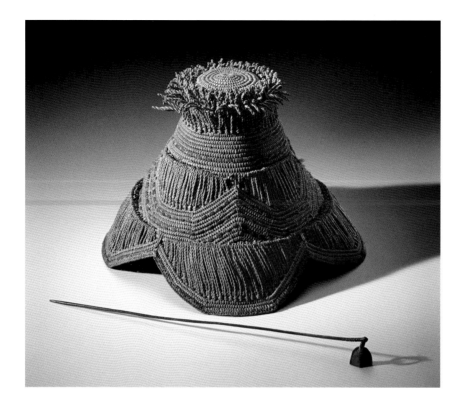

Double-layer man's hat (*lishaash ingyeeng*),
early 20th century
Kuba kingdom, Democratic Republic of the Congo

Raffia, dyed and undyed
H 12.4 cm (4⅞ in.), diam. 19.7 cm (7¾ in.)
Arthur Tracy Cabot Fund and Hy and Shirley Zaret Acquisition
Fund for African Art 2015.2239

Man's Hat, early 20th century
Kuba kingdom, Democratic Republic of the Congo

Raffia, dyed and undyed
H. 14.3 cm (5⅝ in.), diam. 18.1 cm (7⅛ in.)
Arthur Tracy Cabot Fund and Hy and Shirley Zaret Acquisition
Fund for African Art 2015.2241

Hat pin, early 20th century
Kuba kingdom, Democratic Republic of the Congo

Metal
L. 21.6 cm (8½ in.)
Arthur Tracy Cabot Fund and Hy and Shirley Zaret Acquisition
Fund for African Art 2015.2240

Founded in the eighteenth century, the Kuba kingdom in what is now the Democratic Republic of the Congo controlled the lucrative ivory trade of its southern neighbors. By the nineteenth century, this trade wealth supported a great number of court artists, as well as courtiers with the leisure to dedicate themselves to the pursuit of fashion. The simplest form of hat, shown on the right, worn by all adult men, was a four-lobed cap of woven raffia that sat on the crown of the head, held in place by a simple pin pushed through the hair (opposite). Through the 1920s, men in the Kuba kingdom traveled to the court to secure the king's blessing before assuming adult responsibilities, such as getting married. The king would be the first to secure a hat on a man's head. At one time, all men in the kingdom wore a hat, even if they held no title.

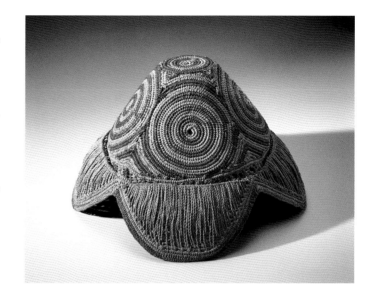

Complex textiles were a daily sight in the Kuba court. The double-layer hat opposite is a masterful elaboration of the simpler hat form and would have been worn by a court herald, a special position that plays a role between the passing of one ruler and his heir's election to the throne. Here a delicate blue color alternates with undyed raffia to create careful patterns. The scalloped design in the central band can be interpreted as a reference to the four lobes that form the border of a normal man's hat and are repeated at the lower edge. The twisted raffia fiber on the lower lobes is repeated on the central level above the blue and raffia scallop, and in the fringe protruding from the top. The hat above is finely worked, although commissioned for a man of lesser rank. Like the double-layer hat, this hat also features the twisted-raffia ornament on the lower lobes. Centered above each lobe, dark and plain raffia create radiating circles; small concentric circles also ornament the crown. The shape of this hat does not suggest any special office for its original owner, but the fine execution and accomplished ornamental details attest to the man's good taste and the artist's skill.

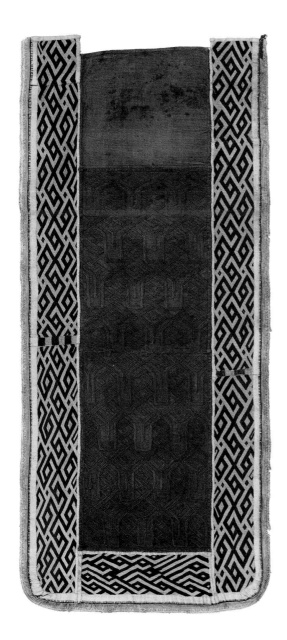

Woman's skirt (*ntchak*), 19th–20th century
Kuba kingdom, Democratic Republic of Congo

To experience Kuba art is to be surrounded by daz-
zling, complicated geometric patterns like the ones
in this woman's skirt (*ntchak*). Kuba courtiers invent
patterns as a respected hobby, akin to writing poetry.
More than two hundred patterns are known, named
for kings, the designers, or the geometric shapes that
they feature. Although patterns are not restricted to
those of noble rank, novel designs or those requiring
greater skill are expensive and therefore likely to have
been made for royalty. This piece would have been
worn as the final section of a lady of the court's skirt,
a length of cloth wrapped many times around the
body with the most ornamented section visible as the
top layer in order to display the masterful weaving
and embroidery. The central panel is raffia cloth dyed
red with additional raffia embroidery in an intricate,
all-over pattern sometimes called "foot of the chame-
leon." Along the long edges, and the short, outer edge
of the skirt, are borders of undyed raffia cloth finely
embroidered with an interlace pattern in dark brown
and natural raffia. Although illustrated vertically
here to focus on the intricate central pattern, this
panel would have been worn horizontally.

Raffia and red dye
L. 74.4 cm (29¼ in.), w. 166.4 cm (65½ in.)
John Wheelock Elliot and John Morse Elliot Fund 1995.90

Pendant showing a king and two dignitaries,

18th–19th century

Benin Royal Bronze Guild (Igun Eronmwon; founded
12th–13th century, Benin kingdom, Nigeria)

Despite its heavy weight, this pendant would have
been worn at the waist of the king, or oba, of Benin
during special occasions. It depicts an oba flanked
by his two most intimate attendants. These special
servants lift the oba's arms for him and are dressed
in the same elaborately beaded coral tunic and crown
as the oba himself. All coral belonged to the king, and
was given to courtiers to wear through his authority.

The high basketry projections on their crowns are
a mark of leadership in this region. The oba also
wears the bead of rule on his chest, an emblem of
authority since the sixteenth century. The artist has
emphasized the importance of the central figure of
the oba not only through his costume, but through
subtle shifts in scale. His calves are stronger and
more fully modeled than those of his attendants,
and his body projects outward towards the viewer,
commanding attention. The braided pattern on his
skirt is echoed in the pair of intertwined mudfish at
his feet. Mudfish are an attribute of the oba because
they live in the rivers during the wet season and
hibernate in the riverbed during
the dry season. This ability to live
in two realms is a metaphor for the
oba's power in both the world of the
living and the spiritual realm of the
gods and ancestors.

Copper alloy
L. 18.4 cm (7¼.), w. 13.3 cm (5¼ in.)
Robert Owen Lehman Collection

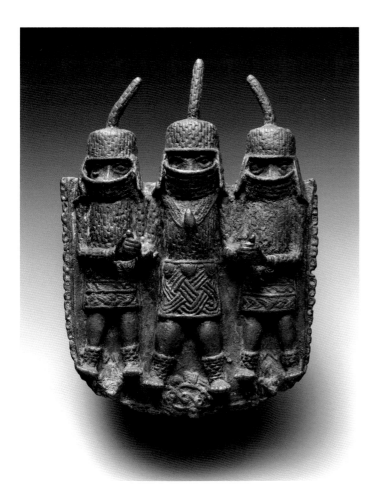

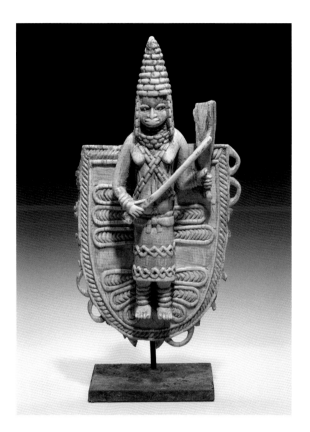

Pendant with a queen mother playing a gong, late 17th–early 18th century
Benin Royal Ivory and Woodworkers' Guild
(Igbesanmwan; founded 10th–13th century,
Benin kingdom, Nigeria)

This small ivory pendant depicts a queen mother (iyoba), the mother of the reigning king, striking a double gong as she might during a public celebration. The iyoba is the only woman with rank and authority in the Benin court. She wears a high coral beaded crown, a beaded collar, crisscrossed beaded bandoliers, and a wrapped skirt possibly embroidered with beads and held in place by a knotted belt. Similar pieces in bronze depict a woman with a musical instrument, but this is the only one known in ivory. Bronze ornaments of this size and shape were used to secure and decorate the knot of a man's wrapper, fine cloth layered around his waist like a kilt. Although the object is thin and fragile, it has a loop in the back that suggests it would have formed a waist ornament for a high-ranking palace official. Today only the king wears ivory ornaments at his waist during special palace celebrations.

Ivory
L. 17.1 cm (6¾ in.), w. 10.2 cm (4 in.)
Robert Owen Lehman Collection

Arched harp (*kundi*), late 19th century
In or near Mangbetu kingdom, Democratic Republic of the Congo

When the ruling families of the Mangbetu kingdom took control of a territory near the Uele River in the nineteenth century, they quickly formed a court renowned for its taste and aesthetic refinement. Mangbetu sculptors developed a naturalistic style with smooth, finely finished surfaces. Made for the pleasure of the king and his courtiers, Mangbetu art features luxury decorative objects like this harp. The harp is made in a form commonly used in the kingdom and the surrounding region, with a tightly waisted body and two round sound holes piercing the sound table at opposite corners. Its gracefully curved neck terminates in a carved head, which is elegantly elongated. Aristocratic women gently massaged and wrapped their infants' heads to achieve this shape, which was considered a courtly refinement at the time.

The Mangbetu court garnered its wealth from the control of regional trade, and European officials visited to seek trading alliances with the king. These European visitors appreciated the anthropomorphic court arts they saw in the palace. During the latter half of the nineteenth century and the beginning of the twentieth, Mangbetu kings actively encouraged artists to create pieces based on the human form to be used as diplomatic gifts for foreign officials.

Wood and cowhide
H. 57 cm (22⅜ in.), w. 14.5 cm (5¾ in.)
Helen and Alice Colburn Fund and William E. Nickerson Fund
1994.194

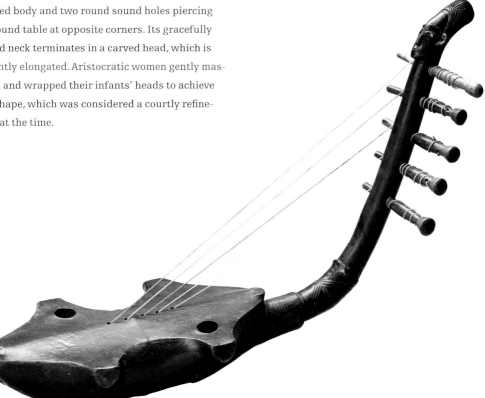

Commemorative head, 15th–16th century
Benin Royal Bronze Guild (Igun Eronmwon; founded 12th–13th century, Benin kingdom, Nigeria)

Copper alloy and iron
H. 21 cm (8¼ in.), w. 15.2 cm (6 in.)
Robert Owen Lehman Collection

Commemorative head, 15th–16th century
Benin Royal Bronze Guild (Igun Eronmwon; founded 12th–13th century, Benin kingdom, Nigeria)

Copper alloy and iron
H. 24.1 cm (9½ in.), w. 16.5 cm (6½ in.)
Robert Owen Lehman Collection

When a royal heir to the Benin crown succeeds to the throne, his first act is to commission a memorial altar for his father. The new oba is not only responsible for requesting the work from the royal bronze-casting guild, but is actually expected to create it himself, either by pouring the molten bronze into the prepared mold or supervising the process. Obas' altars are maintained in the palace for generations, and the most powerful obas have altars befitting their reputation and status as revered, semi-divine royal ancestors. Each altarpiece is part of a larger installation of sculpture integrated into the imposing architecture of the royal court.

The two heads illustrated here represent two separate periods in the long tradition of commemorative heads created for such altars. Both depict an ideal, youthful visage rather than a literal portrait of the king they honor. Both would have been placed on altars in pairs radiating out from the center of the display, with gleaming white ivory tusks rising from the tops of the sculptures. These tusks, kept bright white with citrus juice, created a strong contrast to the bronze sculptures arranged below. Though both heads were created for the same purpose, their styles are dramatically different.

On the left, a young man's face is carefully modeled. The sensitive handling of the full cheeks, the delicate skin below the eyes, and the firm and smooth forehead suggest an artist interested in closely observing the human form. Yet the face is stylized according to Benin conventions, including a sharp, almost horizontal line at the base of the nose and a neatly curving line for the ear. The figure's eyes are decisively outlined, and four raised vertical lines above each brow represent the former facial markings of men in the Benin court. The two longer lines in the center of the forehead, once filled with iron, may represent areas where medicines were applied to protect against spiritual misfortune. Some scholars argue that this figure represents a sacrificial victim, a man seized by the Benin armies in their wars of expansion and brought to the palace as an offering to the king and a proof of victory. But the Benin facial markings, and the head's connection to later examples of this type, make it more likely that he is a member of the court.

On the right, another commemorative head is more richly decorated with the insignia of rank. Here a crown of netted coral beads joins with high coral collars that obscure the man's chin and lower lip. More coral beadwork cascades from the rim of the crown, and agate stones, arranged in small clusters, are gathered over the ears. The artist has dramatized the visible parts of the face to convey a sense of a living presence, the mouth and nose jutting out, the eyes recessed farther into the head.

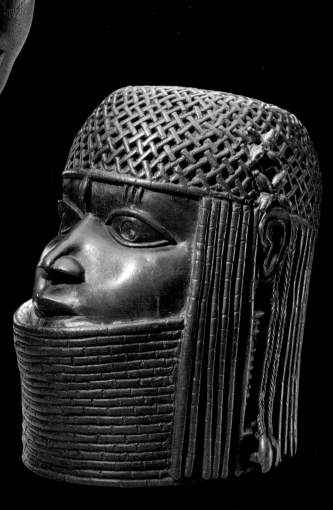

Portuguese soldier, 15th or 16th century
Benin Royal Bronze Guild (Igun Eronmwon;
founded 12th–13th century, Benin kingdom,
Nigeria)

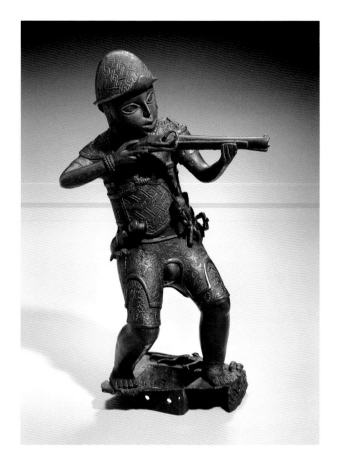

This altar figure wears an engraved helmet donned by Portuguese soldiers in the fifteenth century, as well as a leather tunic intended to protect the torso from arrows. His features, including the long nose with a prominent central ridge, are markedly different from those of Benin courtiers; this man is clearly a foreigner. He carries a short sword or long dagger at his waist and is curiously barefoot. With arms raised and knees bent, this soldier stands ready to fire his rifle. The artist carefully delineates the different patterns of the figure's clothes and the exacting details of his weaponry, and sensitively models his body and stance. The details make it clear that the soldier's weapon is a matchlock gun, newly invented in the 1440s and used into the sixteenth century.

Portuguese traders arrived in Benin in 1485 searching for pepper in order to undercut the prices of Middle Eastern spice merchants. The great quantities of pepper growing on the riverbanks in Benin sparked a regular trading relationship until the early sixteenth century, when pepper was more freely available in Europe and profits no longer justified the long and dangerous voyage to Benin. Portuguese accounts mention that Portuguese mercenaries fought alongside the king of Benin's armies in 1517 to repel an attack by the Idah, a kingdom on Benin's northeast border. It is possible that this sculpture refers to the 1517 battle, a decisive moment in the fortunes of the kingdom and its leaders.

This sculpture would have been surrounded by other figures in bronze, as well as large bronze heads supporting ivory tusks, as part of a royal memorial altarpiece. The square support, now broken, has a flat base designed to rest on an altar's smooth, polished clay surface. In its original content, this warrior was just one small piece of a great assemblage placed in the shadow of the roof ringing a courtyard in the palace.

Copper alloy and iron
H. 40.6 cm (16 in.), w. 22.9 cm (9 in.)
Robert Owen Lehman Collection

Mounted ruler, 15th or 16th century
Benin Royal Bronze Guild (Igun Eronmwon; founded 12th–13th
century, Benin kingdom, Nigeria)

This mounted figure would have stood on a king's commemorative altar, arrayed with other artworks in metal and ivory. The current patina hides the fact that the horse is cast in bronze, while the figure and the base are nearly pure copper, which is notoriously difficult to cast. When originally installed, the sculpture would have gleamed yellow and red.

The figure wears an elaborate crown. A band of coral beads rests on his forehead, and concentric circles of feathers ring the basketry projection at the top that is a regional symbol of rule. The broad, elegant collar with a fringed edge, the leather tunic with cowrie shell appliqués, and the fine, richly woven and embroidered tunic also assert the man's regal authority. The horse is a rare luxury in a region with endemic sleeping sickness, a disease that kills many larger animals. Its presence emphasizes the figure's wealth, and also his ability to easily strike down soldiers approaching on foot. Scholars disagree about whether the figure represents a king of Benin or a neighboring ruler, possibly the king of the Idah, who attacked Benin in 1517. Either way, the square base of the sculpture makes it clear that it was commissioned for a king's altar, indicating that the figure represents an important episode in the king's reign.

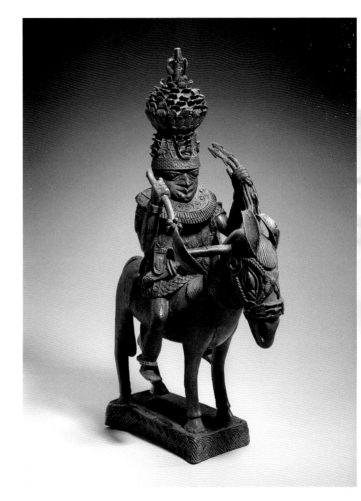

Copper alloy
H. 45.7 cm (18 in.), w. 27.9 cm (11 in.)
Robert Owen Lehman Collection

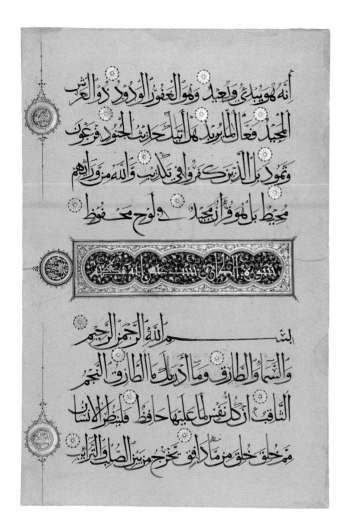

Monumental Qur'an folio, about 1370–75
Mamluk sultanate, Egypt

A ruler's piety is often a rationale for his authority. Like the kings of Benin, who commissioned altars to seek ancestral help, Mamluk rulers of Egypt commissioned artwork to aid in public prayer. During the fourteenth and early fifteenth centuries, Mamluk rulers commissioned huge copies of the Qur'an for public reading in mosques and religious schools. These volumes were written in stately *muhaqqaq* (meticulously produced) script distinguished by tall verticals and bladelike, pointed descending strokes. Rich illumination in gold and colors embellished the beginnings of chapters. This folio, commissioned by Sultan al-Malik al-Ashraf Sha'ban (r. 1363–77), may have been completed by calligrapher 'Ali ibn Muhammad al-Mukattib al-Ashrafi, one of his royal scribes. The text on this page is from Sura 85, verses 13–22, and Sura 86, verses 1–7; the first passage reads in part: "The Glorious Lord of the Throne, He does whatever He will. . . . This is truly a glorious Qur'an [written] on a preserved Tablet."

Ink, gold, and color on paper
H. 75.6 cm (29¾ in.), w. 50.2 cm (19¾ in.)
Denman Waldo Ross Collection 09.335

Basin, mid-13th century
Mamluk sultanate, Egypt

The Mamluk court in Cairo hosted lavish banquets, and this basin may originally have been accompanied by a matching ewer to form a set for washing guests' hands before and during the meal. Much of the basin's silver inlay is now missing, possibly picked out during a financial crisis in the fourteenth century, but it originally bore inscriptions with the royal titles of Sultan al-Malik al-Mansur Qalawun (r. 1279–90). The large inscriptions have been altered to reflect another person's titles; perhaps one of Qalawun's successors had them changed to glorify its new owner, or so that it could be used as a gift.

Objects of this kind, bearing inscriptions for the ruler, were politically useful under Mamluk rule. Bombastic pronouncements about military prowess and royal glory, like those found on this bowl, supported men's claims to authority. In this period leadership was not inherited; any member of the powerful class of enslaved soldiers could, at least theoretically, rise in the political hierarchy.

Brass, with silver and copper inlay
H. 19 cm (7½ in.), w. 46.5 cm (18⁵⁄₁₆ in.)
Gift of Mrs. Edward Jackson Holmes 50.3627

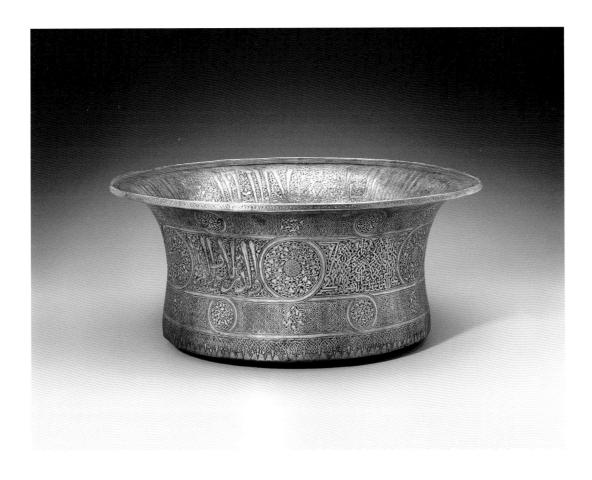

Palace pillar (*opo*), 1912–16
Agbonbiofe (active 1900–1945, Efon-Alaye kingdom, in present-day Ekiti state, Nigeria)

A ruler must be pious but also zealous in guarding his people and their territory. When his palace in the town of Efon-Alaye burned down in 1911, King Arusuboja commissioned a new suite of columns for his audience hall. Agbonbiofe, one of the leading sculptors of the day and a member of the renowned Adeshina family of sculptors, carved seven pillars to support the roof of the open courtyard in the center of the palace. During the nineteenth century, Yoruba kings in southern Nigeria fought for regional dominance. The pillars in an audience hall balanced martial and maternal imagery, assuring the viewer of the ruler's ability to defend his people from attack and ensure the peace and prosperity required to raise a new generation of subjects. This particular column is a fragment; a second figure once stood below the woman's feet. Agbonbiofe has masterfully balanced the body of a beautiful mother with the pillar continuing above her coiffure. The woman's erect posture and serene face resist the heavy functional load of the roof; her calm demeanor is a symbol of the king's good governance. The baby at her breast is gently supported by her left hand, while her right hand caresses the infant's knee. A second child clings to her back. The woman wears an elegant necklace, bracelets, and a lip ornament, but it is her gaze and posture that are most striking, exuding the dignity, safety, and calm secured by the king for his people.

Wood and pigments
H. 147.3 cm (58 in.)
Gift of William E. and Bertha L. Teel 1994.425

Relief plaque showing two officials with raised swords, c. 1530–1570
Benin Royal Bronze Guild (Igun Eronmwon; founded 12th–13th century, Benin kingdom, Nigeria)

Copper alloy
H. 43.2 cm (17 in.), w. 31.8 cm (12½ in.)
Robert Owen Lehman Collection 2018.223

Relief plaque showing a battle scene, c. 1530–1570
Benin Royal Bronze Guild (Igun Eronmwon; founded 12th–13th century, Benin kingdom, Nigeria)

Copper alloy
H. 47 cm (18½ in.), w. 40 cm (15¾ in.)
Robert Owen Lehman Collection

Battle by battle, Benin expanded from a kingdom to an empire. In the sixteenth century, the kings of Benin ruled more than two million subjects in an area about the size of New England. During this period, the sprawling palace in Benin City was made up of many courtyards that could host large crowds, as well as private areas for the royal family and members of the court. One of the courtyards was decorated with more than 850 bronze plaques like these, which were attached to the square pillars supporting the roof of the veranda that shaded the perimeter of the space. Oba Esigie (r. 1517–50s) likely commissioned this massive art project as a way of asserting his authority after a succession struggle and civil war, while his son Orhogbua (r. 1550s–70s) may have completed the vast project after his father's death.

The plaque on the left depicts two senior courtiers with ceremonial swords held aloft. These swords were used in special celebrations at court, when high-ranking men would send them twirling into the air and catch them before they fell to the ground. The figures on this plaque are wearing a wealth of coral beads, which can be seen in their crowns, high necklaces, bands crossing the chest, and anklets. The leopard-face ornaments cinching the men's wrappers, on each man's left hip, also point to the king's power; the Benin king was often metaphorically compared to a leopard, a fast, powerful, and stealthy animal.

The dynamic relief on the right is one of only six in the world that show Benin warriors in action. The plaques were cast to help recount historical events at court; this particular scene may document the conquest of Lagos in the 1550s. A Benin war chief pulls an enemy from his horse and prepares to behead him. The enemy, identified by the scarifications on his cheek, has already been pierced by a sword. The war chief and the enemy, the focus of the scene, are depicted in profile, while other figures appear frontally: two smaller enemies (one hovers above the action, the other holds the horse) and three Benin warriors—one with a shield and spear, one junior soldier playing a flute, and one playing a side-blown ivory trumpet.

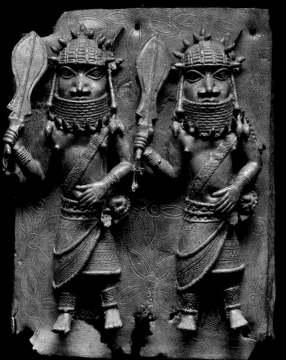

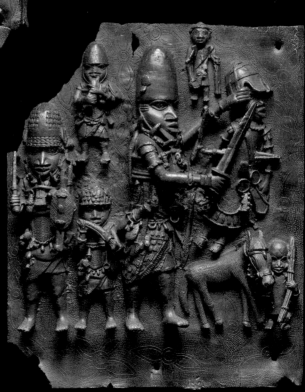

Portrait of a royal wife (*lefem*), 19th–20th century
Bamileke kingdom, Cameroon

This sculpture of an ideal royal wife was never intended to be studied alone, up close. Rather, it formed part of a retinue brought out onto the veranda of the palace on holidays. There, the portraits of the royal family would have been framed by sculptures of men and women carved into the pillars that supported the palace roof. Sculptures of the royal family remained in the shade of the roof, like the royal family members themselves. The artist's choice of strong gestures and expressive facial features would have made this portrait of a royal mother stand out to the king's subjects assembled before the palace.

Grasping her wrist, fist tucked under her chin, the woman's face is raised, her mouth open wide in a laugh or smile. Her knees are gently bent, completing a gesture of respect. The inward curve of her shoulders accentuates the smooth outward swell of her pregnant belly. Her elbows rest on her chest, the outline of her breasts suggesting that this is not the first child she has carried. Meanwhile, the anklets reaching up the woman's calves and the cap on her head indicate that she is no ordinary mother but a royal wife.

The artist has varied the surface of this sculpture: smooth surfaces cover the figure's face and breasts, contrasting with the rougher texture of the body, where the marks of an adze, or woodworking ax, are still visible. The composition is gently angled, with the figure's torso turning slightly to give a sense of movement and vitality that echoes her lively expression.

Wood, pigments, and traces of red and white camwood powder
H. 94 cm (37 in.)
Gift of William E. and Bertha L. Teel 1991.1069

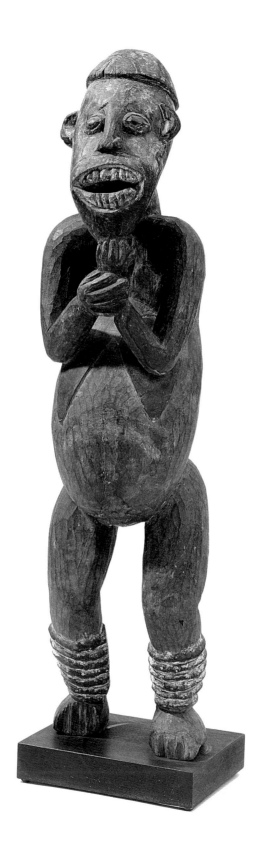

Art of the Shrine

Religious art connects the living world with the spiritual, making intangible belief visible. It can also illustrate sacred history, create a place for spirits to dwell when they are called into communion with the living, and facilitate offerings to ancestors or the gods. Religious tradition in Africa, as elsewhere, has provided worshippers with a way to seek divine aid and protection in this life and a path to follow safely to the next.

The artworks shown here reflect African spiritual practices that were more typical of the nineteenth century than they are of religious belief on the continent today. Although in 1900 the majority of Africans living south of the Sahara practiced their own faiths, more than 80 percent of people living in Africa now follow Christianity or Islam. Christianity has a long history on the continent, from apostolic efforts along the Mediterranean coast in Greek Egypt and Roman North Africa to the conversion of the Ethiopian king Ezana in the early fourth century. Islam was introduced in North Africa in the seventh century, under the Ummayid dynasty. While some Christian and Muslim adherents also follow elements of their forebears' religious practices, many shun mixing faiths as blasphemous. A minority of citizens across the continent continue to practice local beliefs exclusively. This rapid shift from traditional beliefs to other religions across the African continent has been a major factor affecting art patronage in the twentieth and twenty-first centuries.

During the late nineteenth and early twentieth centuries, many Christian and Islamic clerics disparaged local beliefs as paganism and superstition, and African religious artworks were derisively termed fetishes. This biased disdain for local spirituality affected missionaries' ability and inclination to record the precepts and traditions behind the artworks they collected. Where the majority of the population converted generations ago, the original meanings of surviving artworks remain unknown. In other areas, however, local belief thrives, at times in connection with Christianity and Islam. For example, in southern Nigeria

many Christian men and women continue to visit a divination specialist to seek advice on the best course in life.

In any faith, individual believers may find deeply personal meaning in the artworks they encounter in worship that surpasses the canonical interpretations presented here; even fellow believers are rarely able to understand and express the complexity and nuance of these prayerful relationships. As a reflection of the profound connections between objects and their original owners, the artworks here are organized by level of privacy, from sculptures that served only a single worshipper to those used by an entire community. The memorial altar from the coast of Benin, for example, was kept within the walls of a family's compound to provide a place to honor relatives and ask for protection for living descendants. A stone sculpture from Nigeria, in contrast, was set in a circle in the center of town as a public memorial for communal use. The form of each figure reflects the way it was used in worship: small enough to be held in one's hand, or large enough to command attention in the village square; anointed with offerings that denote years of loving devotion, or kept pristine and shining as a symbol of spiritual purity.

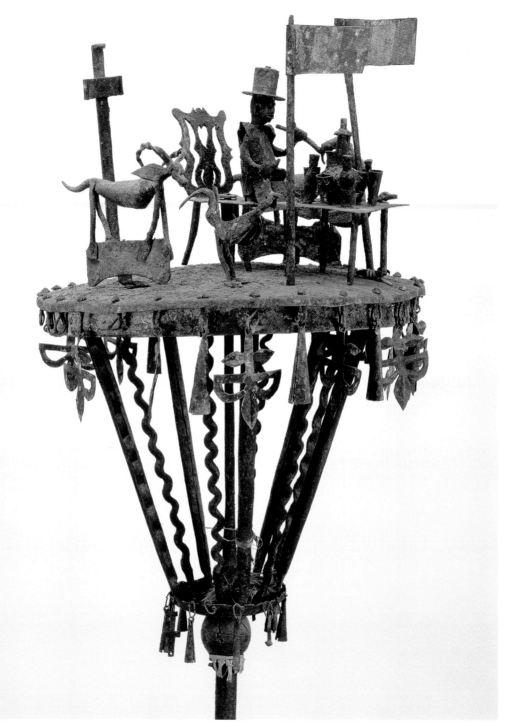

(detail)

Altar (*asen*), mid-19th–early 20th century
Ouidah, Republic of Benin

The surface of this altar for a departed family member was once brightly painted. A wealthy man stands ready to give an address before a lavish banquet. The Chippendale-style chair behind him, the top hat and tunic he wears, and the pipe he carries all suggest fashionable taste and the means to afford the best in life. A goat and a chicken, animals commonly offered in sacrifice to the deceased in well-to-do families, are also included in the scene. Two French flags wave over the table, perhaps indicating the source of the man's wealth. Before 1807, the city of Ouidah was an international center where goods from Europe were exchanged for enslaved men and women captured by the Fon kingdom. By the time this altar was made, however, the terrible trade in human lives had been outlawed in transatlantic trade, and trade in palm oil took its place.

A family would have commissioned this iron altar to be kept in a special room in their home. The altar and others like it offered the living a way to connect with the deceased. At regular festivals of commemoration, important events like a birth or a wedding, or when advice was needed, a member of the family could make an offering of food and seek the counsel of the ancestors represented. Since the eighteenth century, these altars have been a regular feature of life along the Benin coast for prosperous families, much like engraved tombstones elsewhere. The family would have commissioned the particular scene to reflect the life of the deceased, with great emphasis placed on his wealth and success in order to honor his spirit.

Iron and iron oxide encrustation
H. 160 cm (63 in.), w. 43.2 cm (17 in.)
Gift of William E. and Bertha L. Teel 1992.400

Shrine figure, late 19th–early 20th century
Bandiagara cliffs, Mali

The slight body of this Dogon shrine figure is androgynous. The shape of the breasts suggests a woman who has nursed children, but a beard projects from the chin, blurring the specificities of sex to create an idealized ancestor. This sculpture would have been placed in a shrine in the home of the oldest man in the family. Families keep such shrines to honor their ancestors, and the sculpture is viewed as a place for the deceased's spirit to rest when it leaves the body after death. The sculptor's decision to create the form as a cascade of perfect geometry, with strong abstract lines and deep, confident surface markings, would have made the sculpture particularly striking in the raking light coming through the door of the house where it was kept.

The feet, thighs, and hips are tipped at the same echoing angle, creating a curvature in the lower half of the figure that recurs in the cylindrical neck and circular hairstyle. The line of the hips reaches the same plane as the tips of the fingers, and in the hands and torso a rectilinear rhythm takes over. The artist has delicately carved diagonal lines into the shoulders, arms, and hips to accentuate their shape and volume. The double line on the head separates the face from the hair. The briefest suggestion of features on the face creates a delicate profile with parted lips. The weathered stomach and upper thighs contrast with the remains of offerings on the back of the figure, suggesting that this sculpture aided prayerful worship for many years.

Wood
H. 50.8 cm (20 in.)
Gift of William E. and Bertha L. Teel 1991.1068

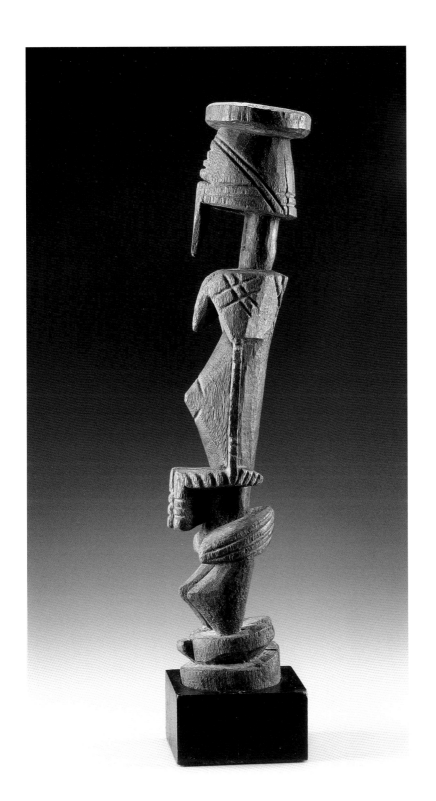

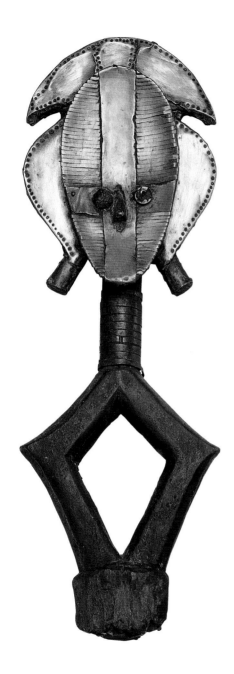

Reliquary figure (*mbulu ngulu*), 18th century
Master of the Sébé (active 18th century, Sébé river valley, Gabon)

Wood and metal
H. 47 cm (18½ in.), w. 16 cm (6¼ in.), d. 8 cm (3⅛ in.)
Geneviève McMillan in memory of Reba Stewart
2009.2696

Reliquary figure (*mbulu ngulu*), late 19th–early 20th century
Haut-Ogooué or Ogooué-Lolo province, Gabon

Wood, copper, brass, and bone
H. 59.7 cm (23½ in.)
Bequest of William E. Teel 2014.327

The faces of these Kota reliquary guardians would have glimmered inside a dimly lit room. On the left, the sculpture's face is highly abstracted, with the eyes and nose centered on wide strips of glowing bronze. Bronze wire, hammered into narrow strips, decorates the rest of the shallow dish that forms the face. One of only nine known figures by the Master of the Sébé, this sculpture was made in Gabon in the eighteenth century. The sculpture has a delicate, diminutive appearance to evoke the face of a younger woman. It would have originally been seen as part of a group of three, along with a senior woman and a man. The sculpture on the right is a rare two-sided reliquary guardian, a type of figure that began to be made in the early 1800s. The convex side, with sheets of smooth bronze carefully attached to the surface, represents a man. The back, with bronze strip decoration similar to the piece made by the Master of the Sébé, represents a woman. On both sculptures, the smooth semicircles on the top and sides of the head represent the figure's hair, and the small spools on either side are earrings. The lower half of the diamond-shaped supports would have been placed inside a reliquary basket, not exposed as they are today.

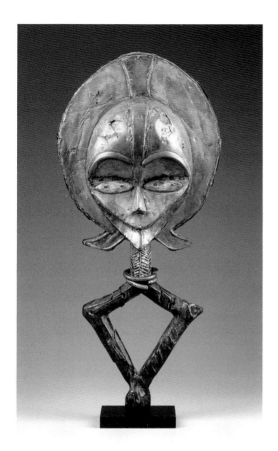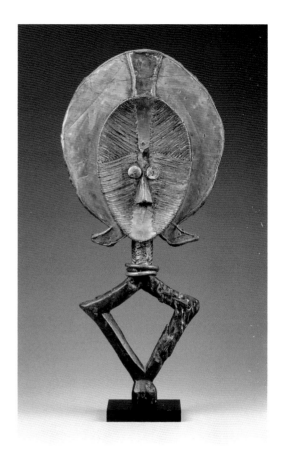

Together, a group of three reliquary guardians—male, senior female, and junior female—represented ideal ancestors whose relics were held in a basket below, though it is not entirely clear how two-sided figures functioned in such a display. Kota communities moved every few years, when the quality of the soil could no longer guarantee abundant crops. Reliquary baskets, like the one these figures would have ornamented, helped families maintain a memorial to their beloved deceased relatives when they moved to a new place. The Kota converted to Christianity beginning in 1900, and reliquaries were no longer kept. Communities abandoned their reliquary figures or destroyed them as proof of their new faith. Local traders, colonial officials, and at times even the missionaries who had encouraged the sculptures' destruction, then sold the cast-off reliquary guardians in Europe.

Shrine figure, 20th century
Kwilu River area, Democratic Republic of the Congo

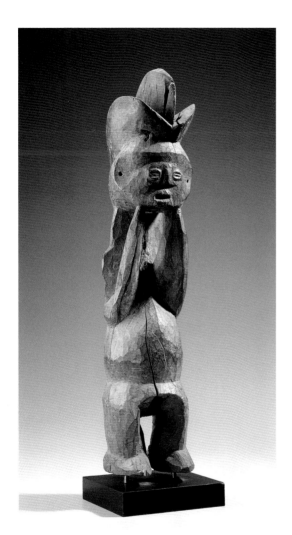

This figure once stood on a table with six or seven other sculptures inside a shrine, or was set outside the door to announce the sacred space within. Its earrings and loincloth are now missing, but the high crests of the hairstyle nod to fashion in the region in the early twentieth century. The figure's mouth is open, as if in speech. Faceted planes set off the expressive face from the hairline, ears, and neck of the abstracted figure. The arms and hands curve upward to touch the chin in an unusual gesture associated with the art of the Huana people.

The Huana migrated north from present-day Angola to what is now the Democratic Republic of the Congo sometime before the nineteenth century. Able blacksmiths, they were welcomed into existing villages founded by other peoples near the Kwilu River. During their migration, some Huana families joined with Mbala clans, and the hairstyle reflects a popular Mbala look. The bulb-shaped torso is also common in Mbala art. Just as Huana smiths shared their skills in their new communities, Huana artists borrowed forms found in the art of their neighbors.

Wood and pigment
H. 61 cm (24 in.)
Gift of William E. and Bertha L. Teel 1994.409

Female figure, before 1930

Near the border of Burkina Faso, Mali, and Côte d'Ivoire

This sculpture of a woman gazes coolly at the viewer, her shoulders rolled forward and hips set back. The large feet give weight and solidity to the small figure. The angular nose, chin, and breasts draw attention to the pointed stomach nestled between shortened arms. The figure's gently turned head, bent elbows, and flexed knees convey a sense of suspense, as if she is ready to respond to someone or something to her right. Beyond the sculpture's formal appeal, however, very little is known of its origins or function. The sculpture was once labeled "Wabembe," a colonial designation for people living in what is now the Democratic Republic of Congo, but the artist's and patron's intentions are unknown.

Likely collected by a colonial official before it was purchased by the American artist John Graham about 1930, this figure's mysterious origins are an example of the erasures that affect African art history as objects move from their place of origin through colonial or missionary collections and on to individual art collectors. As the artwork passed through different hands, details of its original context were lost, or perhaps they were never collected. Yet it is clear that the artist who sculpted this strong female figure was innovative. The figure is not Bembe in style; the artist borrowed elements from styles associated with Senufo, Gurunsi, and other traditions in the area where Burkina Faso, Côte d'Ivoire, and Mali meet. Another nearly identical sculpture is known, indicating that the piece is not a lone experiment, but an innovation that successfully found patronage. Because of the unusual style, however, the sculpture cannot be firmly associated with an art tradition that could shed light on its use and meaning. The artists' creativity makes the lost story of this sculpture even more tantalizing.

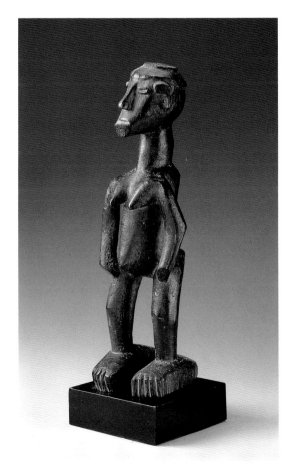

Wood

H. 40.6 cm (16 in.), w. 12.7 cm (5 in.), d. 12.1 cm (4 ¾ in.)

Bequest of William E. Teel 2014.144

Diviner's bowl (*opon igede ifa*),

first half of 20th century

Arowogun (also spelled Areogun, about 1880–1956,
Osi-Ilorin, Nigeria)

With its broad mouth and hinged lid, this bowl once
held the equipment of a successful diviner who could
afford the services of Arowogun, a famed Yoruba
artist living in the Nigerian town of Osi-Ilorin. Aro-
wogun is known for iconography that captures the
tumultuous changes in Yoruba life in the early twen-
tieth century. On the lid of the bowl, a figure rides
a bicycle while smoking a pipe. A colonial officer is
seated on the rear, and a woman perched on the front
fender keeps his pipe filled. The rider is likely Esu,
one of the gods of the Yoruba pantheon, who carries
messages between this world and that of the gods.
He wears shorts and a hat, connecting him to the new
fashions of the colonial state. His central placement
and size in comparison to the small government offi-
cial on the back of the bike suggest Esu's power and
confidence even in the midst of political change.

On the base of the bowl, the images are violent.
Men enslave captured enemies, imprisoning them
with rope and threatening them with swords. After
the fall of the Yoruba kingdom of Oyo in the 1830s,
other kingdoms fought for control of regional trade,
and constant warfare and slave-raiding ensued. The
one quiet figure on the lower half of the bowl is a
woman kneeling and supporting the hinge, a devoted
supplicant sure to find her way through the chaotic
world with the advice of Esu.

In Nigeria and Benin, Yoruba men and women may
consult a diviner when making an important decision
about the future: starting a new business, getting
married, or deciding how to raise a child. After years
of training and apprenticeship, diviners guide clients
using verses of the *Odu Ifa*, a 256-verse compendium
of Yoruba wisdom, selected with the sacred imple-
ments that would have been stored in this bowl.

Wood and pigment traces
H. 31.1 cm (12¼ in.), diam. 29.2 cm (11½ in.)
Gift of William E. and Bertha L. Teel 1991.1066

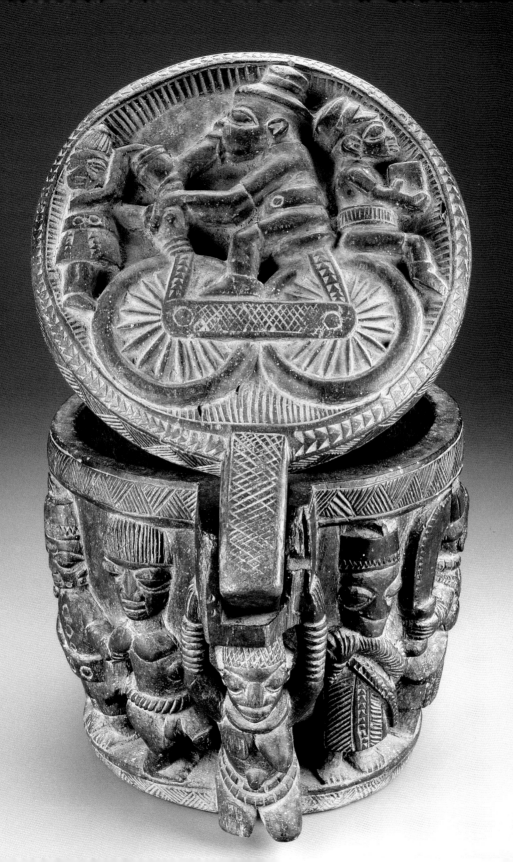

Hornbill sculpture (*porpianong*), early to mid-20th century
Possibly the area around Korhogo, Côte d'Ivoire

Walking outside the limits of a Senufo town, one might have encountered this hornbill sculpture blocking a path. The figure was a warning that the men's society was meeting nearby. The hornbill is considered the foremost bird of the region, and is therefore a symbol of wisdom. The bird's phallic beak and swelling stomach refer to human fertility and the continuation of society. The red and white palette—in stripes on the neck and beak, and in geometric passages on one wing and curving lines on the other—also suggests the dual role of men and women in creating life.

In some Senufo communities, the Poro (men's society) elders instruct boys and young men on spirituality, behavior, ethics, and leadership, so that they may gain the wisdom needed to become productive men. After full initiation into the society, often completed by the age of 30, men are considered ready to lead their communities. The triangular holes decorating the bird's wings are functional places to tie ropes: a new initiate might be selected to carry this heavy sculpture on his head, holding the ropes to balance it, when the group returns to the village or during a member's funeral, showing off the young man's physical strength.

Beginning in 1893, the Senufo region of Côte d'Ivoire was under French rule. This period of colonialism caused great political and social upheaval, and waves of religious conversion as communities sought new ways to cope with the heavy taxes and forced labor of the colonial regime. Massa, a religion and independence movement founded by M'Peni Dembele in Mali in 1946, reached upper Côte d'Ivoire by the 1950s. Conversion to Massa, or alternatively to Catholicism, made sculptures like this one increasingly obsolete. Although bird figures have become a readily identifiable emblem of Senufo culture in the modern tourism industry, by the middle of the twentieth century few communities had the resources or desire to commission a master artist to create such a large-scale sculpture for the men's society.

Wood, metal, and pigment
H. 160 cm (63 in.)
Gift of William E. and Bertha L. Teel 1994.415

Figure (*tadep*), 19th–20th century
Mambila plateau, Taraba state, Nigeria

The abstract body of this Mambila shrine figure, or *tadep*, is unusual. Most tadep figures have a fully articulated body, with a hand raised to the mouth in a gesture of respect. Here, the artist has dispensed with limbs and torso, creating instead a cylindrical base with a graduated column of disks to suggest the body. The folded disk at the center echoes the concave face, and the tilted head gives a sense of personal address. This sculpture is a phenomenal example of the form.

Tadep figures are no longer in use today, and most were purchased from Mambila families in the 1960s and 1970s by art dealers. In the past, however, they were kept in *suaga* shrines. These shrines hold the masks, costumes, and medicines used by the Suaga society, which continues to organize biannual performances to protect the village from harm and serves as a forum for arbitration of community disputes. The shrine is modeled on a granary, a structure raised off the ground on stilts to keep away pests and built with a steeply pitched roof to keep the interior dry, but shrines are easily distinguishable from actual granaries because they lack a fire pit. Larger shrines also have a mural on the outer wall depicting a man and woman standing under a rainbow. Before they fell out of favor, smaller wooden and raffia-pith figures were suspended in a net over the mural in male and female pairs. Smaller figures were visible to anyone visiting the family compound, but larger sculptures like this one were kept inside where only men could see them.

Wood
H. 66 cm (26 in.)
Gift of William E. and Bertha L. Teel 1991.1082

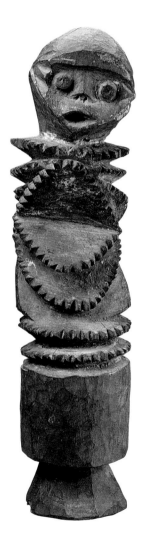

Carved stone (*atal* or *akwanshi*), before 1905
Cross River State, Nigeria

This stone sculpture is one of three hundred monoliths found in villages in the northern Cross River State, Nigeria. The heavy basalt rock, smoothed into an ovoid shape by the current of a river a few miles away, has been carved into an expressive face. The wide eyes and brows are raised in an expression of surprise. The hairline extends beyond the plane of the face, and below the chin abstract patterns cover the area where a torso might be. This example is one of the smaller sculptures, measuring just over two feet, although other monoliths measure up to six feet (180 cm) tall.

The Cross River monoliths were first recorded internationally in 1903 by Charles Partridge, a British colonial officer. Many of the sculptures were found overgrown with vines in the center of abandoned towns. At each site, groups of ten to twenty sculptures were set in a circle facing inward. Local communities embraced the sculptures when they were rediscovered at the turn of the century. Scholars at the time believed that the monoliths represented former leaders of the Bakor clans living in this region. Assuming that each sculpture was made to commemorate a chief at his death, these scholars proposed that the tradition began in the seventeenth century. In the 1990s, however, Chief Alul Nkap, an elder in the village of Alok, explained that the stones commemorated both men and women, clan leaders as well as individuals known for their piety, generosity, remarkable beauty, or remarkable ugliness. The monoliths are now included in the New Yam festival, a celebration at the end of the harvest season. Some families have moved the sculptures into the center of their villages, and women paint the surfaces for the festival to refresh the sculptures and honor the ancestors they may represent.

Basalt
H. 73.7 cm (29 in.)
Gift of William E. and Bertha T. Teel 1994.419

Public Art

Public art draws attention to important people, communal history, shared beliefs, and political issues, and contributes to public discourse about civic life. While some African sculptures are intended to be displayed in private spaces, rarely seen by anyone besides the patron or his or her family, other artworks, such as masks, clothing, and architectural ornaments, are made for a wider audience. The art featured here is encountered on the street or in the center of town, made for the public eye.

Masquerade is a particular type of public art that combines dance, music, costume, and sculpture. Groups of masqueraders and musicians may perform as entertainment or as part of a sacred communication with the spiritual world. In the twentieth century, the performers and their audiences may have different opinions on the purpose of the same performance. In northern Mozambique, for example, some older members of the community consider the performance of *lipiko* an incarnation of ancestors from past generations, while many younger dancers have instead embraced the performance as a way of continuing a cultural tradition and showing off their skills. Although each society has its own reasons for hosting a masquerade performance, harvest festivals, funerals, and the conclusion of adolescents' training are often occasions when one might encounter a masked dancer and his entourage.

Masquerades are generally held in the dry season, when farming work is light and people have the time to gather and celebrate. Performances held during the daytime are much easier to see, and so masks for these occasions often have subtle colors or more intricate detail. Artists creating an ensemble for nighttime performances, or for dances with particularly fast-moving choreography, may choose reflective finishes or bright colors to aid visibility, or may instead leave the finish in a rougher state in acknowledgment of the fact that it will not be clearly seen during the performance. Each mask is only one small part of the masquerade, and many cannot be identified out of context; the character a given mask presents is introduced to the audience through the music or dance steps

that accompany its appearance, not the shape of the mask worn by the dancer. The quick pace and jostling crowd ensure that no two members of the audience experience the masquerade performance in the same way. Some masks appear for the benefit of the whole community, while others have restrictions on who may view them. Men's societies often perform masquerades that are considered so powerfully masculine that they are a threat to a woman's fertility. Heralds precede these masquerades so that women may go indoors before the performance begins. The noises of the masquerade may still be heard, however, making the entire community witnesses to the event, even those who are unable to see it.

While masquerade performances are ephemeral and their separate elements impossible to examine in isolation, architectural ornament and public sculptures are consistently visible. The static presentation of a sculpture on the roof of a chief's home, for example, allows members of the community to study the artwork as well as its significance. The carefully chosen subjects of such sculptures incorporate different layers of meaning, communicating complex messages to the audience that reward repeated viewing.

Finely worked textiles are a more common public sight than masquerade performances, but are not as permanent or public as a sculpture in the center of town. As elsewhere in the world, clothing instantly communicates the wearer's position, wealth, and taste. The textiles shown here were all made in West Africa; some were made by weavers and dyers who knew their client and his or her tastes personally, while others were made to satisfy a distant market, in styles different from the area where the garment was made.

Now removed from their original contexts, these public artworks are experienced much differently. Some, like the masks, are missing the costumes and attachments that once accompanied them, and many are now static instead of alive with movement. All of them once occupied a public, social space. As you read the following pages, imagine catching sight of an architectural ornament in the corner of your eye as you pass a house on a street, or following the motion of a mask worn by an acrobatic dancer. Consider how the grass fibers on a Yaka *kholuka* mask might have sounded as they brushed together, or how precarious the top of a Yoruba *gelede* mask might seem when the dancer tipped forward to execute a particularly strenuous passage of choreography. The artworks here are organized based on how often one might have encountered them, from clothing worn regularly to masks that appear in performance only once every few years. Every artwork illustrated is easy to examine in the gallery or on the page, but would have been seen by its original audience in sudden glimpses.

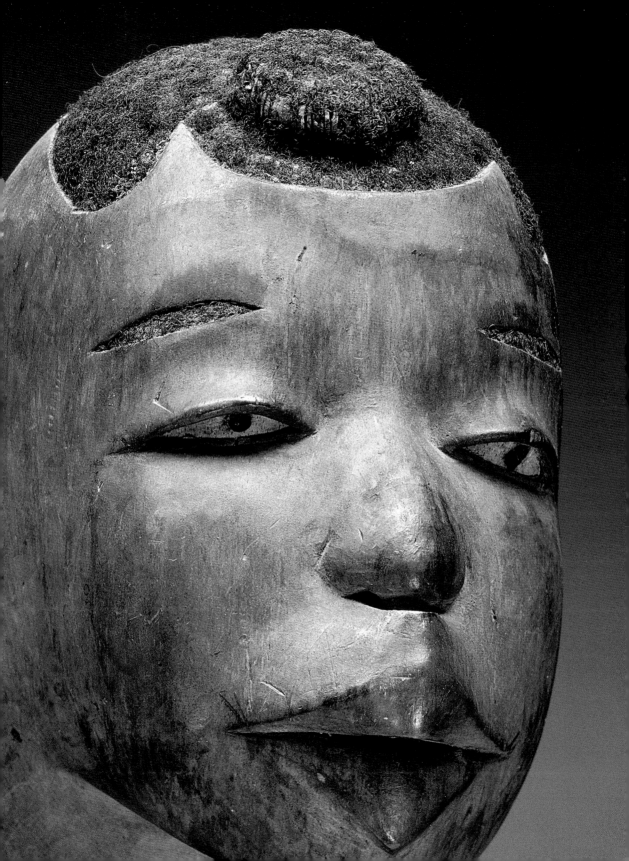

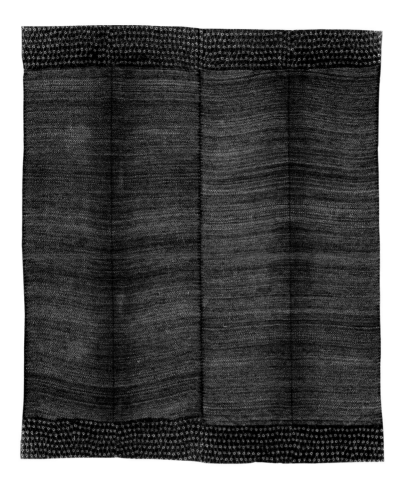

Women's fashion changes at a dizzying pace. These two indigo-dyed cloths were worn as a long skirt wrapped and cinched around the waist for everyday wear. First popular in the 1930s, wrappers made with different tie-dyeing techniques, including stitching or binding fabric tightly together to protect it from dye, had a renaissance in the 1960s. The pattern on the striped cloth incorporates two motifs that were particularly popular in the Yoruba city of Ibadan: small white circles in the border, and stripes in the central panel. The white circles, called a fruit motif, were part of the must-have pattern for 1962; they were made by tying a small stone into the cloth, so that the binding protected the fabric from dye and left a white ring. The stripes, which were all the rage in 1964, were made by folding the fabric and binding it tightly so that white stripes are visible on the final garment.

The overall pattern on the second cloth is a traditional motif that was appreciated in both the 1930s and the 1960s. Unlike the methods described above, this piece required hours of hand-painting with starch to protect the cloth from the dye. After first dividing the cloth into squares, women used cassava flour paste to paint established patterns, and at times, new designs of their own invention. This cloth bears the *Ibadan dun*, or "Ibadan is good,"

Woman's wrapper (*adire alabere iro*),

mid-20th century

Possibly Ibadan, Nigeria

Cotton plain weave, stitch-resist dyed
L. 168.9 cm (66½ in.), w. 196.9 cm (77½ in.)
Gift of Olaperi Onipede in memory of her parents, Dr. F.
Oladipo Onipede and Mrs. Frances A. Onipede 2007.1143

Woman's wrapper (*adire eleko iro*),

mid-20th century

Possibly Ibadan, Nigeria

Cotton plain weave, paste-resist dyed
L. 191.8 cm (75½ in.), w. 167.6 cm (66 in.)
Gift of Olaperi Onipede in memory of her parents, Dr. F.
Oladipo Onipede and Mrs. Frances A. Onipede 2007.1156

pattern, recognizable by the dome on pillars that represents the town hall of this prosperous city. Another square includes a chicken pattern that may allude to the Yoruba creation story.

The beautiful deep blue color is made from local indigo leaves, or from easier-to-use imported indigo grains made by specialists. Indigo dyeing is a com-plex process that requires oxidation to achieve the final color, and older women in southern Nigeria have traditionally been trusted with the responsibility of maintaining the chemistry of the dye vats.

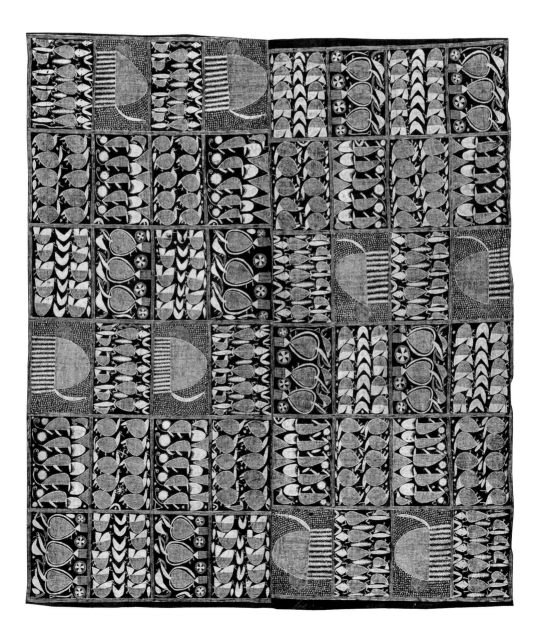

Man's shirt (*agbada*), late 19th–early 20th century
Southern Nigeria

At the beginning of the nineteenth century, Yoruba
men typically wore a length of cloth wrapped around
the waist and secured with a knot. By the end of the
century, men's ensembles were based on fashions
imported from Hausa kingdoms to the north, and
included a loose shirt, like this *agbada*, worn over
drawstring pants. The connections forged by trade
in material goods not only enriched the Yoruba king-
doms and their northern neighbors, but also contrib-
uted to the spread of new fashions.

This agbaba was made with expensive silk and
finely woven cotton for a wealthy owner. The generous
sleeves and capacious central tunic would have given
the wearer an air of comfortable ease. Since Nigerian
independence in 1960, the agbada and pants have
become popular across the nation.

Cotton and silk plain weave, strip-woven and embroidered
L. 124.5 cm (49 in.), w. 259.1 cm (102 in.)
Textile Curator's Fund 2013.1652

Woman's wrapper (*tani fani siri*), about 1950–77
Central Côte d'Ivoire

This wrapper was made by joining separately woven blue and white strips, which were then folded and tied to create bursts of blue color across the surface. This tie-dyeing technique is called *fani siri* in the Dioula (sometimes spelled Dyula) language, and this pattern is popular among Baule clients. The Dioula are Muslim merchants, scholars, and dyers with roots in the kingdom of Mali. They emigrated to establish a trading network across West Africa in the sixteenth century. In communities throughout Côte d'Ivoire, Mali, and Ghana, Dioula men served as textile specialists, with sought-after skills in weaving as well as dyeing with indigo, a particularly demanding natural dye that requires different types of ash, precise stirring, and a certain temperature to work well. Dioula dyers and Baule weavers worked collaboratively, sharing patterns and techniques, and developing new fashions and styles.

Indigo-dyed cloth was once used for everyday clothing for many people in Côte d'Ivoire. When this piece was made, however, fashions were changing. By the 1960s, a woman would have worn a wrapper like this one for a special occasion like a wedding or a funeral, and not as daily dress.

Cotton plain weave, strip-woven and tie-dyed with indigo; glass bead
L. 94 cm (37 in.), w. 157.5 cm (62 in.)
Museum purchase with funds donated by Jeremy and Hanne Grantham 2013.324

Man's cloak (*assia* or *sadjo lokoue*), about 1900
South-central Côte d'Ivoire

Through careful preparation of the material and
painstaking work, a talented woman would have
made this piece by plaiting together individual raf-
fia palm fibers by hand, without the help of a loom.
Areas of the linen-like cloth were tightly bound
before being immersed in a dye bath, resulting in
a tactile map of color; the peaks and valleys of the
cloth are visible even in a photograph. Due to the
intensive, time-consuming labor required to produce
a textile like this one, only wealthy families could
aford to wear such luxurious clothing, and even then
the clothes were reserved for special occasions, like
weddings, the celebration of a new baby, or funerals.
With repeated wear, washing, and ironing, the peaks
formed in the dye process would have stretched out
flat, suggesting that this cloth was purchased for a
collection shortly after it was made.

Raffia, plaited and tie-dyed
L. 151 cm (59½ in.), w. 151 cm (59½ in.)
Frederick Brown Fund, Textile Income Purchase Fund, The
Elizabeth Day McCormick Collection, by exchange, and Alice
J. Morse Fund 2000.575

Man's wrapper (*kente*), about 1950–89
Asante kingdom, Ghana

Cotton plain weave with supplementary wefts, strip
woven
L. 304.8 cm (120 in.), w. 195.6 cm (77 in.)
Museum purchase with funds donated by Jeremy and
Hanne Grantham 2004.196

Man's wrapper (*kete*), about 1950–89
Ewe nation, Volta region, Ghana

Cotton plain weave with supplementary wefts, strip
woven
L. 275.6 cm, (108½ in.), w. 160 cm (63 in.)
Museum purchase with funds donated by Jeremy and
Hanne Grantham 2004.197

When Dr. Kwame Nkrumah, the first president
of newly independent Ghana, spoke out against
the forces of imperialism to the United Nations
General Assembly in New York in 1960, he wore a
striped *kente* cloth wrapper as a political state-
ment. Nkrumah and his ministers determined that
the newly independent nation should celebrate its
art traditions—associated with the historic sover-
eignty of Akan kings—from the outset. In the inde-
pendence era, when the Ewe and Asante examples
shown here were made, kente cloth became a marker
of national pride in Ghana and an international sym-
bol of self-rule for members of the African diaspora.

In producing kente cloth, a tradition that dates
to the eighteenth century, Ewe and Asante weavers
share many of the same techniques, introduced by
Saharan traders across West Africa in the eleventh
century. Weavers use an upright loom to weave long
strips that are then sewn together to create the
garment. The weft-float techniques visible in both
textiles involve an extra heddle on the loom—
a complicated technical detail that makes each side

of the cloth unique. The Asante cloth pictured here
is called *Asebihene*, meaning "for the Asebi chief,"
highlighting the royal patronage associated with
Asante weaving. The pattern includes rich passages
of white—a color used for special occasions—
and deep indigo. The Ewe cloth has a profusion
of color and geometric motifs to dazzle the eye.
It may be a *susuvu* cloth—a term meaning "my skill
is exhausted," indicating that this is the weaver's
best work. Although Asante and Ewe traditions are
often discussed in contrast because of their different
aesthetics—pattern based versus free form—some
weavers produce kente cloth in both styles.

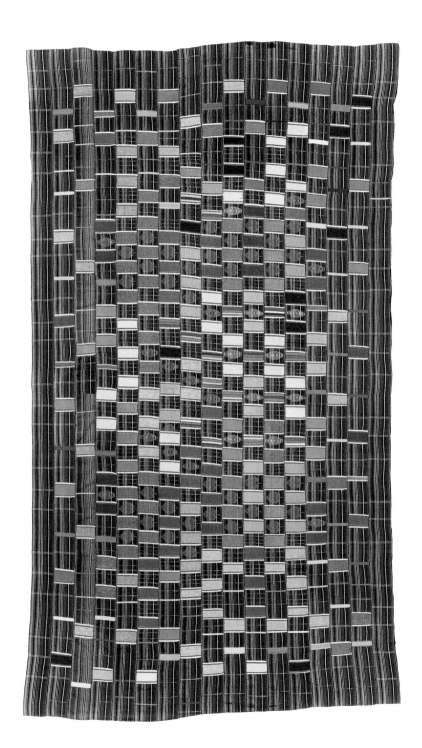

Water jar, 20th century
Niger state, Nigeria

In the nineteenth and early twentieth centuries, young women learned how to make pottery from their mothers before establishing families of their own. Terracotta water jugs were once readily found in family compounds across northern Nigeria. The basic form of this vessel is modeled on a dried gourd, a simple natural container, and is one of the most recognizable forms of Nupe pottery. The artist responsible for this pot has subtly stylized the shape by creating a flat passage near the neck. The round lower chamber holds a great deal of water, while the narrow neck and dishlike rim help keep the liquid from sloshing out of the vessel when it is moved.

Nupe water jars were in high demand for their handy engineering, as well as for their attractive geometric designs. Especially talented potters may have sold their wares through traders across the region. Wealthier people could afford water jars with incised lines, such as these, as well as passages of red and black; the richest clients would have hired a metalsmith to create bronze fittings to further embellish their housewares.

Terracotta
H. 41.9 cm (16½ in.), w. 33 cm (13 in.)
Gift of Olaperi Onipede in memory of her parents Dr. F. Olapido Onipede and Mrs. Frances A. Onipede 2010.951

Rooftop finial (*kishikishi*), 1960s–70s
Kisakanga, Democratic Republic of the Congo

The chief of Kisakanga, a Pende village now called
Kisanga in the Democratic Republic of the Congo,
commissioned this sculpture for the roof of his house
in the 1960s or 1970s. The unusual finial in the shape
of a Kipoko mask was a firm rebuttal of his subjects'
allegations of sorcery—defined as using spiritual
help for selfish aims. In the Eastern Pende area,
Kipoko is considered the most beautiful and the most
powerful of all the masquerade personas. His danc-
ing combines choreography that demonstrates cour-
age, wisdom, eloquence, and leadership—all qualities
of an effective chief. Kipoko's kicking dance step
activates spiritual help for the sick and infertile. By
placing a sculpture of a Kipoko mask on his home, the
chief asserted that he judiciously used his communi-
cation with the spiritual world only for the benefit of
the community.

Most Pende rooftop finials at this time depicted
a mother and child. In the 1940s, the artist Kaseya
Tambwe Makumbi began carving figures of mothers
holding infants on one hip and a sword in the oppo-

site hand, a subject that quickly
became the most popular choice
for a chief's home. The mother and
child imagery alludes to a chief's
responsibility to both nurture
his people and zealously defend
them from attack. This Kipoko
finial spreads a similar message
through an entirely different
image, one that points to the
owner's proper use of spiritual
power.

Wood and pigment
H. 45.7 cm (18 in.)
Arthur Tracy Cabot Fund and Hy and
Shirley Zaret Acquisition Fund for
African Art 2015.2235

Altar to the hand (*ikenga*), about 1910
Oroma Etiti Anam village, Aguleri-Nteje region, Nigeria

At first glance, the spiraling superstructure of this *ikenga*, or "altar to the hand," seems delicate and fanciful. Upon closer inspection, however, the different elements all celebrate aggression. The sculptor carved a man sitting with spine straight, head held erect, his mouth stretched into a grimace. The intertwining snakes, rams' heads, bats, and leopard above his head allude to qualities of stealth, perseverance, and stubbornness that are valued for helping a man succeed. An ikenga celebrates a man's accomplishments thus far in life. The sculpture is both a monument to what its owner has achieved through the work of his own hands and a site that facilitates prayer and sacrifice to ensure his future accomplishments. The solidity of the powerful seated figure contrasts with the empty central axis of the animals whirling above.

The daring composition was devised by an experienced artist working around 1910 in the village of Oromo Etiti Anam. The size of the sculpture suggests that it was commissioned by a highly successful man living in an Igbo-speaking village or town in eastern Nigeria. The diagonal lines on the man's forehead are a mark of leadership in the Ozo organization, a group of spiritual leaders. Men of all stations in life could own an ikenga. More modest examples may incorporate only a suggestion of rams' horns on top of an abstract cylindrical form, and would have been kept in the owner's home. A masterfully carved piece like this one, however, may have been kept in a community shrine. The sculpture suffered some damage—and repair—on its journey. The hand holding an ivory trumpet, the right arm and dagger, and the right foot were added to the sculpture between 1977 and its donation to the MFA in 1994, likely by a dealer or prior owner.

Wood and pigment
H. 109.2 cm (43 in.)
Gift of William E. and Bertha L. Teel 1994.421

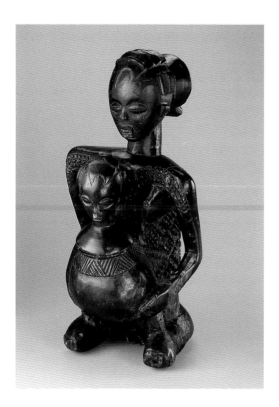

Bowl bearer (*mboko*), 1910–30s
Attributed to *Kitwa* Biseke (active 1910–1930s, near Mwanza, Haut-Lomami region, Democratic Republic of the Congo)

This sculpture of a mother holding a small child, whose body conceals a bowl, was a luxurious embellishment for a simple gourd that held sacred white chalk, possibly placed at the entrance to a chief's home. It is similar in appearance to seven other sculptures likely made by the same artist, *Kitwa* Biseke, whose work was photographed in the Nkulu chieftainship in Shaba province of what is now the Democratic Republic of the Congo in the 1920s or 1930s. The woman's cowrie-shell-shaped eyes, with full circles ringing her nearly closed lids, the sharp angles of her shoulders, and her abstract, shortened legs with small struts supporting the bowl all link this piece to Biseke's workshop, while the hairstyle and the scarification patterns on the torso are classic fashions across the Luba kingdom. *Kitwa* means "a chief's personal woodcarver," and Biseke worked for chief Nkulu; for this reason, it is possible that the sculpture was made for Nkulu to use himself or give as a gift. Chief Nkulu would have expected guests to daub themselves with chalk from a small gourd placed in the bowl of this sculpture, charmingly topped by the child's head, as a sign of respect before greeting him. The chalk, associated with the shining whiteness of the moon and the spiritual world of the ancestors, invoked blessings.

During the nineteenth century, the strength and wealth of Luba kings led to an increase in royal commissions. But through taxation, occupation, and forced labor, the Belgian colonial government eroded local political structures throughout the Congo in the early twentieth century, eroding patronage for royal arts. At the same time, Protestant missionaries in this region sought to convert local leaders, and to have them burn artworks perceived as "fetishes." Biseke completed this artwork at a time of intense social change, when traditional patronage was on the decline.

Wood
H. 47 cm (18½ in.)
Gift of William E and Bertha L Teel 1996.386

Bowl lyre (*ndongo*), 19th century
Buganda kingdom, Central region, Uganda

This bowl lyre, or *ndongo*, has no bridge to lift its
strings from the surface of the sound table, so the
strings vibrate against the rough, scaly surface of
the monitor lizard–skin covering, creating a distinc-
tive buzzing tone unique to the instrument. It was
made in the nineteenth century, before the monitor
lizard became an endangered species. Tassels of
goat hair or cow's tails always adorn the ends of
the wooden yoke that carries the strings. Without
them, the joint between the yoke and the supporting
arms would look unduly "naked," to quote James
Makubuya, a contemporary ndongo player.

Although the ndongo is not a common instru-
ment today, it is still played. The harp was a familiar
sight at weddings and festivals in the nineteenth
and early twentieth centuries. It is often part of
an ensemble of fiddle, flute, and drum, but its more
significant use is to accompany a solo singer whose
songs serve three important roles in Ugandan culture:
teaching moral conduct, storytelling, and instruct-
ing a newlywed couple through bawdy songs sung
on their wedding night. In each of these practices
the performer's playing is largely improvised and
involves complex rhythmic patterns played in a very
rapid and percussive style, though the instrument
has only eight strings tuned in a pentatonic scale.

Unlike European harps, whose notes are strung
sequentially from low to high, the lowest strings of
the ndongo are in the middle and the higher ones to
the sides. The strings are wrapped around the yoke
with a tuning loop, a wooden rod that can be twisted
to change the pitch of the strings. Unless it is being
played with other instruments, the ndongo is simply
tuned to suit the performer's singing voice for a par-
ticular piece.

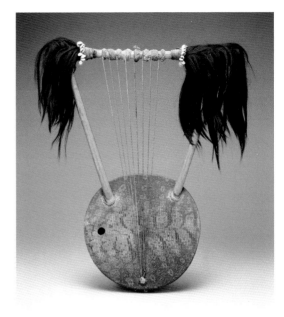

Wood, monitor lizard skin, goat hair, and cowrie shells
H. 66 cm (26 in.), w. 53.5 cm (21 in.)
Leslie Lindsey Mason Collection 17.2179

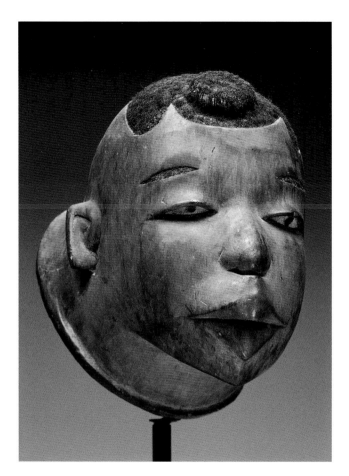

Dancing with quick steps in the center of town, two men would have supported these masks on the tops of their heads, their eyes looking out from the mouth of the mask. The smooth skin and finely carved eyes and ears of each mask create an idealized face; the slightly parted lips seem ready to speak. The mask with the turban depicts a Sikh trader from abroad, while the one with closely shaved hair portrays a local Makonde man. A fabric ruff and a tight costume would have concealed each dancer, leaving only his hands and feet visible to the crowd. In collaboration with the sculptor and the musicians, a young man would have commissioned a mask and developed a new choreography to express its character. The dance is both a celebration and an opportunity for public examination of important topics—politics; recent events in the village, such as a scandalous romantic affair; or daily events like cooking, reading, or hunting—communicated through both realistic representation and satire. In performance, the *lipiko* is simultaneously considered an ancestral spirit, a man, and a character in the narrative of the dance.

These particular masks were both made during a time of significant political change in the Mueda plateau, an area in northern Mozambique. The Portuguese occupation of Mozambique had previously not reached this area, but when Portuguese businesses began to see the plateau as a resource for cotton production, political domination quickly followed. The colonial government used forced labor and tax laws to ensure a steady supply of laborers on plantations and cotton for textile mills in Portugal. Village elders

Mask (*lipiko*), about 1930–55
Mueda plateau, Cabo Delgado province, Mozambique

Wood, hair, and pigment
H. 22.2 cm (8¾ in.)
Bequest of William E. Teel 2014.315

Mask (*lipiko*), about 1930
Mueda plateau, Cabo Delgado province, Mozambique

Wood and paint
H. 33 cm (13 in.), w. 17.8 cm (7 in.), d. 25.4 cm (10 in.)
Peter von Burchard in memory of Gisela and Joachim von Burchard 2014.1968

were pressured to cooperate with the colonial state. In response, thousands of young Makonde men and women moved north into Tanzania, returning home to visit with new ideas and imported luxuries. During this period, the style of Makonde masks changed. The abstract idealism evident here, with tiny lines conveying the nostrils, and delicate spirals to indicate the ears, began in the 1930s. This style may have been developed by older men, who wished to assert the ancestral component of the masquerade that younger people increasingly challenged. Younger dancers in this period also commissioned masks in the abstract style but introduced new subjects, like the Sikh trader, to convey the increasingly cosmopolitan faces of Makonde daily life.

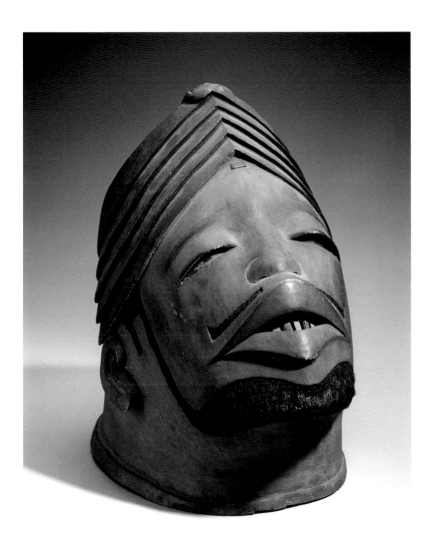

Sango staff, early to mid-20th century
Ijomu village, Ora-Igbomina region, Nigeria

Masterfully sculpted by an artist in the village of Ijomu
in the Ora-Igbomina region, this dance staff is topped
by a female figure whose perfectly smooth skin glows
in the light, her diamond-shaped eyes half-opened.
When not in active use, its fine details would have been
visible on an altar to Sango, a deified former king of
the Yoruba city of Oyo. In public, the staff would have
been carried by a woman or man inducted into the
priesthood of Sango. These priests invite Sango to pos-
sess them, making the deity accessible to the gathered
worshippers. In this possession trance, the priests
dance with a sculpture like this one held in their left
hands, a signal that the occasion is outside of the realm
of normal life, where one would use the right hand for
most tasks.

 A Sango priestess stands atop the staff, her knees
flexed and body bent forward from the hips, ready
to dance. The child strapped to her back turns its
head to look to the right, its hands curled under the
woman's arms in a tender gesture. The baby refers
to Sango's power in granting children, as well as to
the woman's purity. Young Yoruba mothers remained
celibate until their children had finished nursing, a
practice considered beneficial to their spiritual life.
Perched above the woman's hair, a double axe, with
an ornamental pattern on the wrapped portion in the
center, creates a sort of crown. The axe is made of two
stones called celts, thought by devotees to have been
sent by Sango, who is associated with thunder and
lightning, and collected in Sango's shrines. The celts
on this dance staff are the most important element of
the staff from a spiritual perspective, while the fine
sculpture of a mother in the center of the staff draws
the eye.

Wood

H. 54.6 cm (21½ in.)

Gift of William E. and Bertha L. Teel 1991.1070

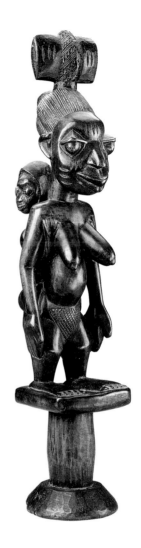

Men's society flag (*asafo frankaa*), before 1940
Possibly by Nana McCarty (known as Mr. Mankato,
birth name Kwame Boah, died in 1940), Anomabo
workshop (active about 1880–about 1995, Anomabo,
Central region, Ghana)

Since the seventeenth century, newly elected officers
of *asafo* companies, or militias, have commissioned
flags like this one to decorate their meeting halls,
dance competitions, and mock battles. Asafo militias
formed to protect their towns from invasion during a
period of political turmoil in what is now Ghana. Yet
even as the threat of invasion from other kingdoms

receded in the mid-nineteenth century, Fante men continued to join asafo companies as social organizations similar to the Freemasons.

On this flag, a man stands to the left, with one foot in front of the other, and the flying grasses tied to his left arm suggest that he is in rapid motion. The birds in the center are busy as well: one is in flight, two are eating fruit from a tree, and others stand in the center. The iconography of asafo flags asserts the superiority of the commissioning company against their rivals, but the exact subjects are usually understood only by men within the local companies. The red bird in the center anchors the composition, while the delicate embroidery creating the tree and details of the birds and figures gives greater visual interest when viewed up close. The man's slender body, his embroidered ears, and the dark-brown cotton used for his skin are similar in style and technique to the known works of Nana McCarty, founder of the Anomabo workshop. The Union Jack in the upper left corner is also made in the style of the workshop and ties the flag to the period of British occupation, before Ghana gained its independence in 1957.

Appliquéd cotton and plain weave, embroidered and appliquéd
L. 99.1 cm (39 in.), w. 152.4 cm (60 in.)
Gift of Mary H. Kahlenberg and Robert T. Coffland 2004.2278

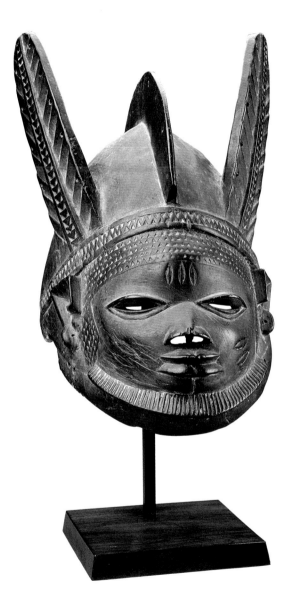

Gelede headdress, 19th century
Master of Anago (active 19th century, Anago, Plateau
department, Republic of Benin)

Wood and pigment
H. 41.9 cm (16½ in.)
Gift of William E. and Bertha L. Teel 1991.1081

Gelede headdress, early to mid-20th century
Duga of Meko (also called Doga of Imeko, about 1880–
1960, Imeko, Ogun state, Nigeria)

Wood and pigment
H. 54 cm (21¼ in.), w. 55 cm (21⅝ in.), d. 42 cm (16½ in.)
Geneviève McMillan in memory of Reba Stewart 2009.2717

Two celebrated artists carved these masks for the
gelede festival, a celebration in honor of mothers.
With origins in the eighteenth century, the gelede
festival still occurs in most Yoruba cities and vil-
lages once a year, with dancing beginning in the late
afternoon and continuing until the early hours of
the morning. In Yoruba thought, a woman who has
reached menopause has a special spiritual status,
because her gender identity has shifted from the
procreative female toward the male. She also has for-
midable social power, as a mother, a mother-in-law,
and often a grandmother. Gelede dancers celebrate
women's contribution to their families and communi-
ties, tease them about gossip and nagging, and cajole
them to use their powers for family and community
harmony instead of sowing discord. The different
demands of day and night performances and the var-
ied tone of the dances give artists room to experiment
with color and form, constantly innovating within
this long tradition.

The two artists responsible for these masks
worked on either side of the border between Benin
and Nigeria. Both have sculpted the face and head
of the mask as a rounded form, with swelling cheeks

and temples. Their shared emphasis on the nearly spherical presentation of the face is in keeping with Yoruba aesthetics, but from this point the artists' compositions diverge. The Master of Anago has created a striking form with two wooden feathers rising from the top of the mask, their height balanced by the crest in the center of the hair. The surface is smoothly finished, with clusters of parallel lines called *abaja* on each cheek and *pele* on the forehead. These incisions were considered beauty marks in southwestern Yorubaland when the mask was carved. The artist has added a band of incised triangles to the forehead and temples, a decoration of his own invention. The rectilinear ears are a particular signature of the artist. The paint that was once applied to the mask was likely removed by a European collector.

Duga was an innovative sculptor from the Nigerian town of Meko who trained with master artists in the town of Ketu, Benin, the same region where the Master of Anago worked. Duga rejected his predecessor's compact composition for a boisterous image of a woman earning money in the market. The mask balances an entire business on its head—the tea things, sugar, storage basket, and tray of a market vendor. Below the tray, the face of the mask juts forward. The large eyes, pronounced nose, and tight lips are emphasized by a carved representation of a fabric tie looped around the head, its ends resting in graceful arcs that suggest the dancer's movement.

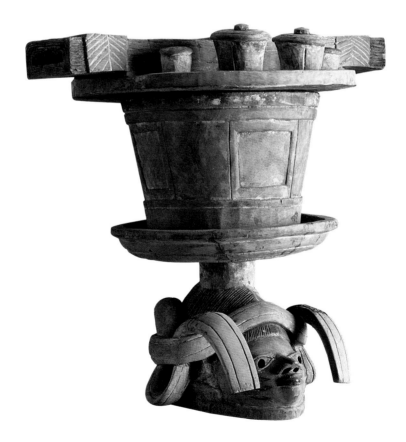

Karanga mask, Yatenga style, first half of 20th century
Northwest Central Burkina Faso

Wood and pigment
H. 142.2 cm (56 in.), w. 15.8 cm (6¼ in), d. 18.5 cm (7¼ in.)
Gift of Carolyn and Eli Newberger 2014.2277

Karanga mask, Risiam style, early to mid-20th century
Central Burkina Faso, early to mid-20th century

Wood and pigment
H. 96.5 cm (38 in.), w. 10.2 cm (4 in.), d. 24.1 cm (9½ in.)
Gift of Eli and Carolyn Newberger 2005.1198

These two masks both combine different human and ani-
mal features but are named for a large breed of antelope
(*Hippotragus koba*), locally called a *karanga*. The masks
were used in dances during the dry season before plant-
ing; their reddish color echoes the red clay of the land
at this time of year and the fine red dust that settles on
houses and plants. Mossi farmers used the masks as a
form of prayer for the orderly progression of the seasons
from the dry period to the rainy season, when fields are
transformed with lush vegetation. Although the masks
and decorative patterns are abstract, both artists have
included references to the natural world: two stylized
antelope horns rise from the Yatenga mask's face, and a
bird's beak arches up from the top of the Risiam mask.

Owned by the head of a large family, each mask was
made to commemorate an important spiritual protector.
For example, the mask with horns may have been made in
memory of a moment when a member of the family was
lost in the woods and an antelope appeared to show him
or her the way home, or when a man went hunting in dire
need of food and found a herd of swift antelope standing
still, as if waiting for him. The family would honor the
spirit that had inhabited the antelope in these times of
need by commissioning a mask and using it in family cel-
ebrations, including memorials to the deceased. When the

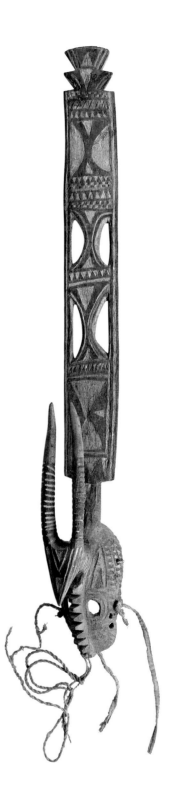

mask was not in performance, it served as a family altar. Particularly powerful spirits might be consulted by those outside the family, who would come to ask for protection from illness or a solution to infertility.

The Mossi Empire was founded at the beginning of the sixteenth century by warriors from Ghana. The newcomers rode north on their horses and established kingdoms, and those local people who weren't able to flee elsewhere became tax-paying subjects. The descendants of the warriors derived power from their ancestors' significant military expertise, while the descendants of the local people claimed power over the spirits that control the environment, resulting in a kind of detente between the two groups. Masks like these establish the spiritual mastery of the conquered local farmers, called *nyonyosé*. The style of each mask reflects the ancestry of its makers. One mask has a tall plank with pierced openings rising from the face below. The face itself is in the popular Yatenga style; it is highly abstracted, with two holes for eyes and a single raised line down the center to suggest nose and mouth. The tall, openwork panel is similar to the masks of the Dogon people, who lived in this area before the Mossi invasion. The other mask is likely from Risiam, where artists use a convex shape that is borrowed from neighboring Kurumba peoples. Both Dogon and Kurumba peoples were incorporated into Mossi society as nyonyosé, and their descendants continue to use aesthetic forms of their ancestors.

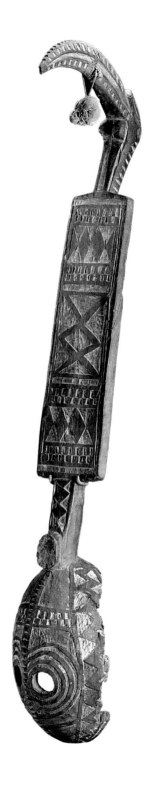

Helmet mask for the Sande society (*ndoli jowei*), before 1960

Eastern Sierra Leone

This mask is the embodiment of a perfectly beautiful, well-behaved young woman. The dark, smooth surface is punctuated by a bright star on the forehead. The downcast eyes and resolutely closed lips reflect the expectations for well-brought-up young women, who are told to keep their own council and not to meet the eyes of elders, strangers, or men as a sign of respect. The mask's smooth, lustrous surface has been oiled and evokes the perfect glowing skin of a teenage girl. The folds around the neck likewise point to an ideal beauty: a woman who is well fed but not

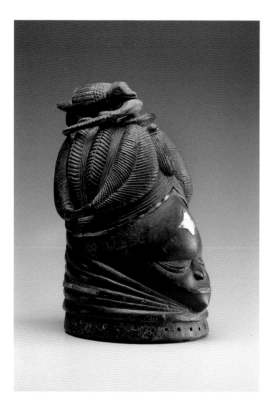

heavy, and who takes care with her appearance. The elaborate hairstyle is too complex for everyday wear for all but the wealthiest of women. All women, however, are entitled to a time-consuming hairstyle on the day that they are "pulled," or graduate, from the Sande society, an occasion when masks like this one appear.

Sande, a women's society in Sierra Leone and Liberia that dates back to the seventeenth century, trains girls to become women. Outside of the bounds of town to allow for privacy, older women circumcise girls to mark their entry into womanhood and teach them important skills for their future lives as wives and mothers—sex education, basic midwife skills, and how to get along with their future mother-in-law. Girls also learn the secrets of Sande: dances, songs, and advice known only to the women of a community. For example, the reptile on the top of this mask may refer to an aphorism or song known in the community where the mask was commissioned.

Sande society masks are the only wooden masks in Sub-Saharan Africa made for and performed by women. A woman who has attained a certain level in Sande may commission a mask, usually after she has been visited by a spirit in a dream. The masks are used in performances before and after initiation, when a woman dies in childbirth, or at women's funerals. Women in a given community compete with each other in performance, aiming to be judged the best dancer or to have the prettiest mask. The ornate carving, bright metal accents, and intriguing animals on this mask likely made it a crowd favorite.

Wood and metal
H. 35.5 cm (14 in.), w. 20 cm (7⅞ in.), d. 25 cm (9⅞ in.)
Gift of Geneviève McMillan in memory of Reba Stewart
2009.2727

***Kholuka* mask for the Nkanda society,**
before 1959
**Bandundu province, Democratic Republic of the
Congo**

Dancing into the village square, a young man
would swing this *kholuka* mask over his shoulder
with a flourish. The crowd might already have
started to titter. Kholuka masks are part of the
final performance in a celebration of adolescent
boys' entry into the world of men, and the masks
have a bawdy appeal. The bushrat peering over
the front of this mask has overly enlarged geni-
tals, for example. The animal's position suggests
that it is not merely sitting on the head of the
dancer but ready to mount it. The crude iconog-
raphy contrasts with the fine ornamental details
in the paint that remains on the animal and the
abstracted face below. The upturned nose on the
face is a hallmark of Yaka art that some relate to a
powerful elephant's trunk or an erect phallus.

In performance, the dancer holds the mask in
front of him, raising it like a scepter to highlight
particularly fast and intricate choreography,
vibrant painted colors adding flash to this
gesture. The accompanying music mocks local
politicians, neighborhood cheapskates, and other
members of the community who make life diffi-
cult for their neighbors. Most of all, however, this
mask and its performance mock women. Making
lewd jokes and hurling insults, the performance
breaks all the traditional taboos of Yaka society,

giving young men a chance to bond with their elders
before the men's society festivities are over. This
breech of protocol traditionally occurred only every
few years, when a new group of boys completed the
preparations for manhood. Audiences remember
these infrequent performances well, and often com-
pare the jokes and masks of one celebration to previ-
ous occasions.

Wood, pigment, cloth, and raffia
H. 57cm (22⅜ in.), w. 40 cm (15¾ in.), d. 44 cm (17⅜ in.)
Gift of Geneviève McMillan in memory of Reba Stewart
2009.2698

So'o Mask, 20th century
Katanga province, Democratic Republic of the Congo

This mask opens its mouth wide in an otherworldly leer. Meant to represent a chimpanzee-human, the mask is a mash-up of civilized human life and the chaotic, animal savagery of the forest. The artist has captured this liminal status in the mask. Its features are almost human, with a thin nose and sweeping brows. Hemba viewers would see the mouth not as a smile but as a terrible, gaping grimace.

This terrifying mask would have been worn at formal memorial services held a year or two after the death and burial of an important member of the community. Hemba communities have historically celebrated no other major festivals, and so periodic funerals serve as occasions for a community reunion that friends from far-off towns travel to attend. Before the performances, the masquerader ran through the town streets, scaring children and pregnant women, who fled immediately upon his approach. The masquerader would have appeared ungainly and disconcerting, with no visible arms and remaining silent, signaling his presence only through his mad dash and the sound of iron bells. During performances by other groups, the mask loses its terrifying aspect and instead mocks the graceful or intricate movements of youthful dancers. This mask may represent mortality, and its capers may help people cope with the dreaded reality of death.

Wood
H. 18.4 cm (7¼ in.), w. 14.6 cm (5¾ in.), d. 6.4 cm (2½ in.)
Gift of William E. and Bertha L. Teel 1992.407

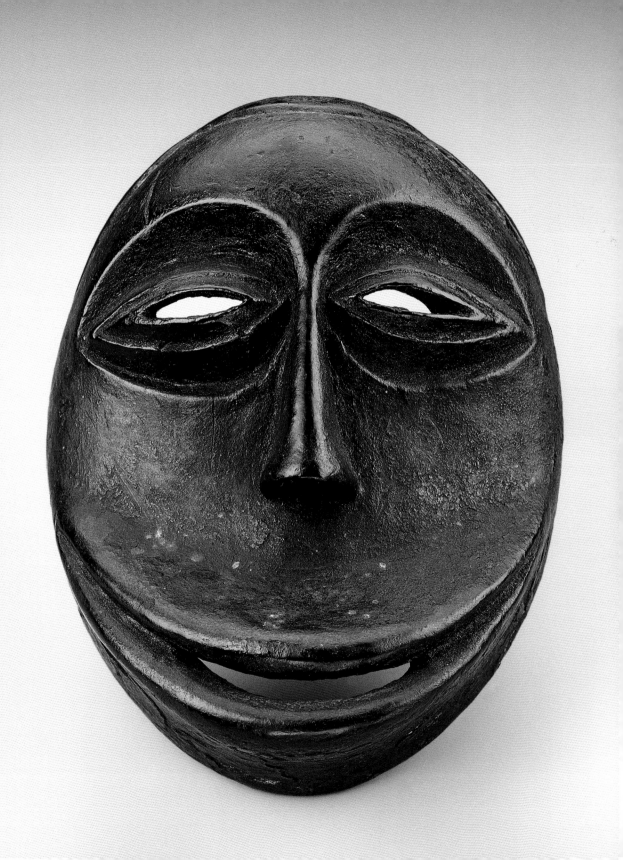

Global Art

In the internet age the world seems a single, connected place. The ease of connectivity may be new, but worldwide interconnectedness is not. Africa has been involved in far-reaching trade networks since the time of the Pharaohs, and traders and travelers have brought with them new goods, ideas, and forms of art, which have been absorbed into African culture and traditions. The artworks highlighted here reflect this global exchange.

The adoption of new religions has had a great impact on African art. Christianity and Islam both reached the continent soon after each religion was founded, but the influence of Islam on African art is more visible in the MFA collection, which contains celebrated examples of Islamic art made for communities in North and West Africa. Beginning in the seventh century, followers of the prophet Mohammed found refuge in what is now Ethiopia. Over the following century, Islam spread through North Africa. By the tenth century, the Almoravids, kings ruling in what is now Morocco and Mauritania, converted to the faith, spreading Islam farther south through their trading networks with the kingdom of Ghana. On the east coast, the kings of Zanzibar, in what is now Tanzania, converted in the eighth century. One of the five main precepts of Islam is that all Muslims who are able should travel to Mecca on a holy pilgrimage, or *hajj*, at least once in their lifetimes. The injunction to make a hajj ensured a connection between Muslims living in Africa and those in the Middle East. Objects made for Islamic patrons in Africa, such as a Qur'an and a man's robe, reflect the aesthetic of this global religion.

African and Middle Eastern markets were connected not only through the hajj but also through trade. Since the fifth century, caravans across the Sahara brought gold from West Africa to markets in the Middle East and Europe in exchange for salt. Beginning in the fifteenth century, Portuguese innovations in shipbuilding made regular coastal trade possible as well. Ships from Portugal, the Netherlands, France, and England quickly established trading posts along the West African coast, seeking pepper, ivory, palm oil, gold, and,

most notoriously, enslaved people. Traders also purchased luxury goods for the European market. An Egyptian carpet and a saltcellar from Sierra Leone are both examples of artwork made for export to a wealthy international clientele. A Mangbetu container, sold in the late nineteenth century, was likely made for a similar purpose centuries later: to provide traders with a luxury souvenir.

The advent of photography also facilitated international connections. By the 1840s, the first photography studios were operating on the continent, shortly after the 1839 discovery of the daguerreotype in France. In the 1870s and 1880s, commercial photo studios became more common in larger cities. Photographs made for affordable souvenirs or mementos for local and international audiences alike, and well-to-do families had their portraits taken in the studio to share with friends and loved ones. Colonial officials and missionaries used photographs to record images of people in unfamiliar dress or practicing local cultural and religious customs. Savvy European and African photographers sold postcards to a European market awash in the hugely popular mail medium—billions of postcards were sold between the 1890s and 1940. Postcards included photographs of people as well as landscapes, although the postcards' subjects were not always aware that their likeness would be used in such a commercial way. Some studio photographers were paid for their work twice—once by the sitters, and again when the photographer used the private portrait to print public postcards. Photography continues to be a popular medium in contemporary African art practice, due in part to the commercial success that photographers have enjoyed throughout the twentieth century.

In the same period that photography swept through the continent, colonial governments established universities according to the European model in order to train staff to work for the state. These schools included art departments that gave instruction in life drawing, painting, stone sculpture, and other European art forms. By the mid-twentieth century, students rejected this Eurocentric model of art instruction, instead seeking a modern art that respected the artistic traditions and aesthetic aims of their own countries. El Anatsui was one early proponent of using locally available materials to develop a formal art language that participated in the global contemporary art conversation, instead of adopting media with European origins. Contemporary art in the late twentieth century continues to grapple with the legacy of European occupation, whether through formal questions like Anatsui's or through conceptual investigations.

The pages that follow include artworks made by African artists influenced by foreign ideas, including some celebrated examples of Islamic art made for communities in North and West Africa. The list of artworks inspired by African

ideas and aesthetics is similarly long. The MFA collection includes Haitian religious paintings inspired by Yoruba art and religion, African American painting and sculpture that embraces West African aesthetics, works by French modernists that were directly inspired by sculpture and textiles from Africa and Oceania, and contemporary art that responds to pottery and jewelry traditions from the continent. The exchange of ideas and art forms between artists working on different continents over time presents a conversation on art, life, and the cosmos that started in antiquity and has continued to the present.

Rug, mid-16th century
Mamluk sultanate, Egypt

Wool is spun counterclockwise just about everywhere in the world except for Egypt, where it is spun clockwise. This distinctive feature allows us to identify this carpet as Egyptian in origin. The carpet's design, however—a central medallion surrounded by star-shaped motifs, with a profusion of intricate vegetal forms and interlacing patterns throughout— finds its roots in regions that extended beyond Egypt to Anatolia and parts of present-day Syria, Armenia, Azerbaijan, Iran, and Iraq. To distinguish their carpets from those made in other lands, weavers in Mamluk Egypt appear to have made some effort to create a carpet "brand" intended specifically for the European export market. The pile of their commercially produced carpets—antecedents to this one—often includes five colors and omits the undyed white wool that was common to other carpet-weaving traditions of the same period. After the Ottomans conquered Egypt in 1517, the production of carpets in Cairo continued, though with some modifications, including the reduction of the pile's color palette to three similarly saturated hues—red, green, and blue. The startling visual impact of this arrangement is evident here thanks to this carpet's extraordinary state of preservation. An additional clue that Europe may have been this carpet's target market is the square format, adopted after European clients were found to place expensive imported rugs on a table instead of the floor to protect them from wear.

Wool warp and wool weft with wool knotted pile
L. 268.9 cm (109 ⅞ in.), w. 278.9 cm (105 ⅞ in.)
Helen and Alice Colburn Fund and Harriet Otis Cruft Fund
61.939

Door frame from a *minbar*, 14th–15th centuries, with later additions
Mamluk sultanate, Egypt

This amalgam of woodwork from various periods has been at the MFA since it was pur-
chased at the 1876 Centennial Exhibition in Philadelphia, the first world's fair to be held in
the United States. There it was a highlight of the Egyptian section, shown alongside carpets
and a plaster cast of Ramses II, and presented as "the door of a mosque from Cairo carved
and inlaid with ebony and ivory, and dating from the fourteenth century," as J. S. Ingram
described it in his 1876 commemorative catalogue *The Centennial Exposition Described and
Illustrated*.

The door's assembly was probably overseen by a French architect and art dealer named
Ambroise-Alfred Baudry (1838–1906), who designed buildings and houses in Cairo and
supplied them with Mamluk and Mamluk-revival furnishings. The door combines a panel
from the era of Sultan al-Zahir Barquq (r. 1382–89, 1390–99) with elements salvaged from
fourteenth- or fifteenth-century Mamluk doors, or possibly from a *minbar*, a type of pulpit
found in mosques. The frame seems to have been part of a minbar at one time; cavities, nail
holes, and ivory inlay reveal where doors and a stair railing were once attached.

The oldest part of this composite is the horizontal panel at the bottom, made from worn
Aleppo pine and bearing faint traces of pigment and inscribed in Arabic: "Honor to our
master the sultan the king . . . al-Zahir Barquq. God magnify his victory." The panel likely
comes from a door within a complex Barquq had constructed in central Cairo between
1384 and 1386. As the complex was in considerable disrepair in the nineteenth century, it is
possible that Baudry was able to purchase elements salvaged from the building and have
his carpenters incorporate them into new pieces of woodwork, endowed with grandeur and
a patina of historical greatness.

Wood (ebony, Aleppo pine, abura, and boxwood) and ivory or bone
H. 258 cm (101½ in.), w. 95.2 cm (37½ in.), d. 17.8 cm (7 in.)
Gift of Martin Brimmer 77.1

Saltcellar, late 15th–early 16th century
Coastal Sierra Leone or Guinea

Three men kneel atop this ivory saltcellar, a luxurious souvenir brought to Lisbon from the coast of West Africa by Portuguese traders. Salt was an expensive commodity in this period—placing salt in an elaborate saltcellar made its presence on the table more conspicuous to guests. More than fifty West African saltcellars (or sections of them) have survived to the present, usually in the curiosity cabinets of European royal households. It is unlikely that this saltcellar was heavily used, based on the condition of the interior of the globe where salt would have been stored.

Some elements of this saltcellar represent the client, likely a Portuguese merchant, while others were added by the artist who worked on the Guinea coast. The kneeling figures in Portuguese tunics, the hunting scene on the base, the oak-leaf pattern, and the form of the saltcellar itself would have been shown to the artist on playing cards or etchings supplied by his client. The curling snakes, prominent birds, interlace pattern, and bands of small, inset spheres were likely part of a longer Sapes (sometimes written as *Sapi*) tradition. The identity of the Sapes artist and the specifics of his training are unknown, but new research demonstrates that a bustling market in spoons, saltcellars, and other ivory works existed in what is now Sierra Leone through the seventeenth century. Such items were made for sailors as well as for a cosmopolitan local market of European settlers fleeing religious persecution in Portugal.

Ivory
H. 25.4 cm (10 in.), w. 10.2 cm (4 in.)
Robert Owen Lehman Collection

Diadem (*tassabt* or *ta'essabt*), 1860s–90s
Kabylia, Algeria

A young woman might have received this beautiful diadem as a gift from her parents in Kabylia, a region along the Mediterranean coast in Algeria. The geometric shapes in the center are hammered silver ornamented with green and blue enamel on both sides and set with coral on the front. Small enameled beads flank the central rectangle, while numerous silver half-spheres and delicate wire connect the sections of the diadem together. The small diamond and teardrop shapes at the bottom are also finished with enamelwork, and would have moved against the forehead when worn; the pins at the top helped to secure the jewelry to a headscarf.

Amazigh (formerly called Berber) parents use a dowry payment to purchase jewelry for their daughter to wear on her wedding day and afterwards. Husbands added to their wives's collections throughout their lives together; today, many women also select jewelry for themselves. In 1866, countrywide famines plagued Algeria, and in 1871 the French occupied Kabylia and seized farms from local residents to give to French settlers. Many dispossessed families were forced to sell their jewelry to survive. The French occupation of northern Algeria led to a growing number of colonial officials and tourists in the area; the newcomers admired Amazigh arts and began buying jewelry and pottery as souvenirs. This diadem was purchased by Arthur Croft, the husband of donor Caroline A. Croft (née Brewer), during a trip to Algeria in the 1880s. At the time of his visit, new jewelry pieces were made specifically for the foreign tourist market, although jewelers also continued producing for local clients.

Silver and enamel set with coral
L. 45.3 cm (17⅞ in.), w. 18.5 cm (7¼ in.), d. 0.8 cm (⅜ in.)
Bequest of Mrs. Arthur Croft—The Gardner Brewer Collection
01.6452

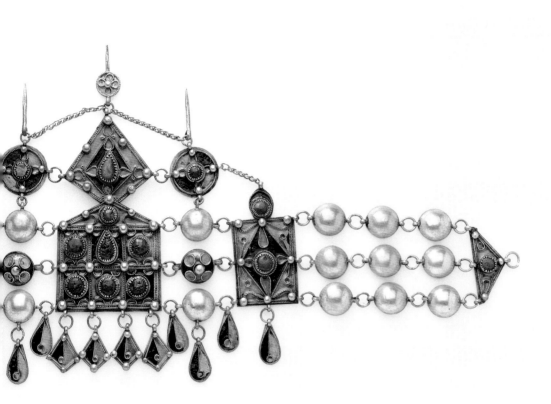

Female figure, 1850–94

Attributed to the Master of the Flat Hands (active 1890s, on or near Bonthe Island, Sierra Leone)

The graceful tilt of this sculpture gives a sense of movement to the elegant woman depicted with her arms at waist height and her knees bent. Her expression is reserved, with eyes nearly closed and mouth slightly pursed. The artist has accentuated the woman's high forehead with a fashionable coiffure, its central crest directly aligned with the woman's pert nose. The neatly carved passages of braiding along the woman's hairline echo the triangular scarification pattern on her abdomen. The hairstyle, scars, and ridged neck, which Sherbro women created through bindings, point to a woman committed to fashion and beauty. The herniated umbilicus and the elongated breasts both suggest that this woman has borne many children.

This is the earliest collected sculpture by the Master of the Flat Hands, an artist active in the late nineteenth century on or near Bonthe Island in Sierra Leone. Seven sculptures of women, as well as three masks, a staff, and a palette, are recognized as the work of this artist, whose name remains unknown. The sculptures all share the elongated neck and torso, angular arms, pendant breasts, decorated stomach, herniated umbilicus, and sharp, angular shape of the bottom visible in this figure.

In this region of Sierra Leone, sculptures of women were used as memorials or for local political and religious societies. Given the excellent condition of this sculpture, though, it was probably purchased directly from the artist before it could be locally used. In the 1890s, the artist was most likely producing pieces for a local clientele as well as for foreigners passing through the busy port on Bonthe. Shipping manifests confirm that Dr. Fitzmaurice Manning, whose granddaughter donated this sculpture to the MFA, lived in Sierra Leone in 1894, where he likely purchased the artwork as a souvenir.

Wood

H. 78.5 cm (30⅞ in.), w. 13.8 cm (5⅜ in.), d. 15.3 cm (6 in.)

Gift of Helen Howe Braider in memory of Fitzmaurice Manning 2017.854

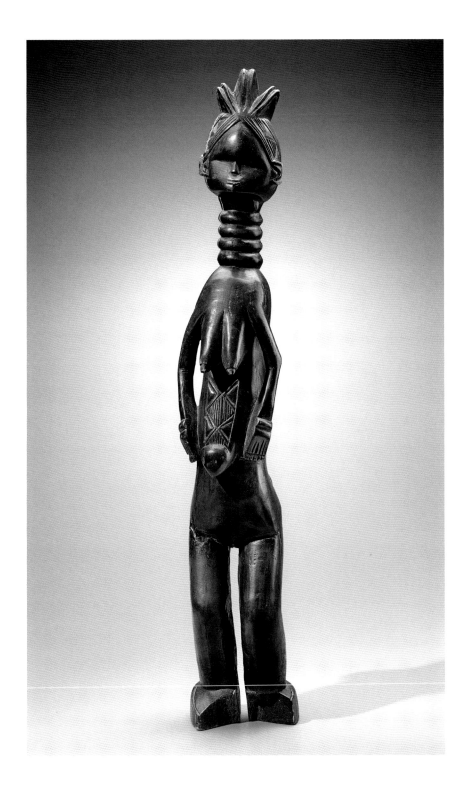

Bundoo Girls, Sierra Leone, about 1908
Alphonso Sylvester Lisk-Carew (1883–1969, Sierra Leonean)

Lisk-Carew Brothers, Photo., Freetown, Sierra Leone. Registered.
BUNDOO GIRLS, SIERRA LEONE.

The three young women in this photograph are dressed in similar clothing, but their expressions couldn't be more different. Fashionably tied head-wrappers and chevron-patterned tops cover their hair and breasts for modesty; the necklaces and bracelets, as well as their fine skirts and the prominent white cloth wrapped around their hips, indicate their status as new graduates from training in Sande, the women's society in Sierra Leone and Liberia. Completing their initiation in Sande, sometimes called Bundu (spelled "Bundoo" on the card), marks the transition from girlhood to womanhood, and the sitters' fine ensembles are a symbol of their new status as adults. The woman standing on the right seems to be smiling with pride, while the woman seated gazes warily at the camera. The youngest woman, standing on the left, looks off into the distance, as if preoccupied with her own thoughts.

The women were photographed in an urban studio in front of a backdrop that evokes a Victorian mansion, including a dramatic staircase on the right, pilasters and wood paneling on the left, and a distant garden framed by columns. Such backdrops were common among the many competing photography studios that began advertising their services in Sierra Leone by the late 1860s. Alphonso Lisk-Carew, who opened his studio in 1903, became Freetown's most celebrated photographer, receiving commissions from colonial officers and British royalty, as well as elite citizens of Sierra Leone. It is likely that the sitters' wealthy family (or families) commissioned this portrait to mark the occasion of the girls' graduation from Sande. Lisk-Carew then repurposed the image for distribution as a postcard. The subject of women's initiation societies would have been fascinating for Freetown urbanites who were unfamiliar with Sande, as well as for colonial officers and foreign visitors.

The caption on the postcard pushes this portrait into a recognized genre of postcards capturing "local types" viewed through colonial tropes of the exotic foreigner, and it highlights the challenging political period that spanned Lisk-Carew's career. The photographer worked for colonial authorities, and during World War II he accepted a commission to create propaganda photographs despite local opposition to Sierra Leone's involvement in the war. Yet Lisk-Carew also had an association with the pro-independence *African Times and Orient Review* and maintained his opposition to colonialism throughout his life. Lisk-Carew's career exemplifies the way artists and businessmen continually negotiated their difficult positions during colonial occupation.

Postcard, collotype on card stock
H. 14 cm (5½ in.), w. 8.9 cm (3½ in.)
Leonard A. Lauder Postcard Archive—Gift of Leonard A. Lauder 2012.4919

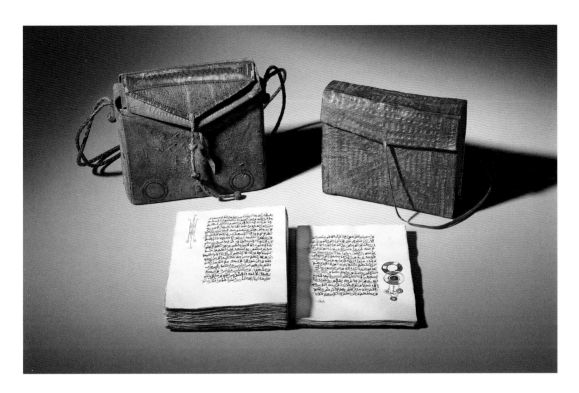

Qur'an manuscript with cover and satchel, 19th century
Northern Nigeria

This Qur'an merges Italian paper with the script and decorative style of Islamic communities at the border of Chad, Niger, and northern Nigeria. The text is written in a loose derivative of Maghribi script from North West Africa, and is ornamented with bold, relatively simple decoration rendered in earthy tones of yellow, ochre, red, and occasionally blue. The unbound folios are loosely held within a wraparound leather cover secured with a long leather thong. A leather satchel with a carrying strap makes the folios more easily portable, an important feature for patrons who traveled frequently. In the eighteenth and nineteenth centuries, wealthy traders in the Bornu and Hausa regions to the west of Lake Chad owned similar portable Qur'ans.

This Qur'an is written on paper with a watermark attributable to the nineteenth-century paper mills of Valentino Galvani and family in the Venice-Trieste region of Italy. The *tre lune* (three moons) watermark with a stylized face was first used by Galvani around the turn of the nineteenth century and was continued, in slightly evolved forms, by his descendants until around 1880. A number of manuscripts made in northern and eastern regions of Africa in the nineteenth century used paper with this watermark, indicating that such Italian paper was widely available.

Ink and gold on paper, leather
L. 23.5 cm (9¼ in.), w. 21 cm (8¼ in.), d. 7.5 cm (3 in.)
Denman Waldo Ross Collection 15.132a–b

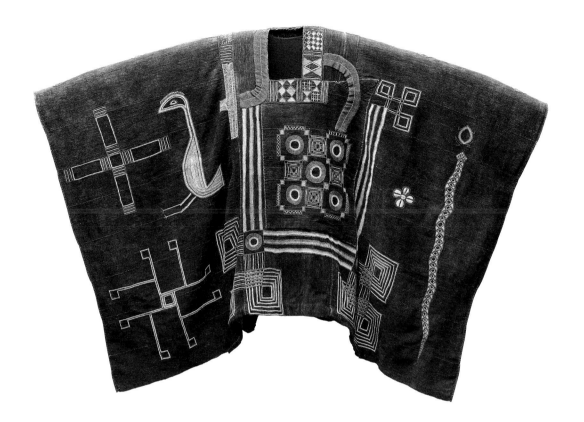

Man's robe, 1920s–30s
Mandingo trading networks, Liberia

White and red embroidery glows against this deep
indigo robe once owned by a Mano chief living
in Blaui, a small town in northern Liberia. The
narrow neck of the garment, edged in red appliqué
and squares with intricate embroidery patterns,
created a small box around the wearer's neck that is
repeated in the geometric patterns below. Together,
these motifs are called *hatumere*, an Islamic design
sometimes used for protective amulets or healing
prayers with the worshipper's name inscribed in the
center. Further elaborations on the square motifs and
a bird adorn the right arm, while a set of embroidered
cowrie shells set in a blossom design and a wriggling
snake chasing a frog ornament the left arm.

The front of this garment is spectacular, but the
reverse is even more impressive. Although twenty-
three robes from this period exist in international
collections, only five bear the figural decoration found
on the back of this piece. Mounted riders, identified
as powerful warriors by the leopards depicted below
them, flank a nude man. All the figures hold their
arms aloft—the riders to control their horses, the
central figure possibly in a gesture of surrender.
Above the riders' heads are mancala game boards
and birds, which would have rested on the owner's
shoulders when he wore the robe. The symmetrical
composition displays a great variety of embroidery
patterns and color, giving a sense of individuality to
each of the paired figures. The fine condition of the
fabric suggests that this garment was worn only on
special occasions.

This piece was purchased from its owner by Alfred Tulk, an artist who was visiting his university friend, Dr. George Harley, in Ganta in northern Liberia from 1931 to 1933. Although the original owner's name was not recorded, it is likely that he purchased this robe from a "Mandingo" trader—that is, an itinerant Islamic trader from Mali who worked in the border area where Liberia, Guinea, and Côte d'Ivoire meet. This robe tells an important story about changing style in men's dress during the nineteenth century, when desire for these Islamic-inspired "boubou" swept through West Africa. Most men wore the robes so that they fell at mid-calf, but this one falls at the knees, a length fashionable only in Liberia. The red silk threads were reused from old British uniform fabric, another link in a global chain of fashion and exchange. The man who sold the robe to Tulk may have done so to earn money for taxes: in the 1930s, the coastal Liberian government had recently required all householders to pay their taxes in cash, a great burden on northern communities who traded primarily by barter.

Cotton and silk
L. 91.4 cm (36 in.), w. 167.6 cm (66 in.)
Gift of Margarete L. Wells 2017.4649

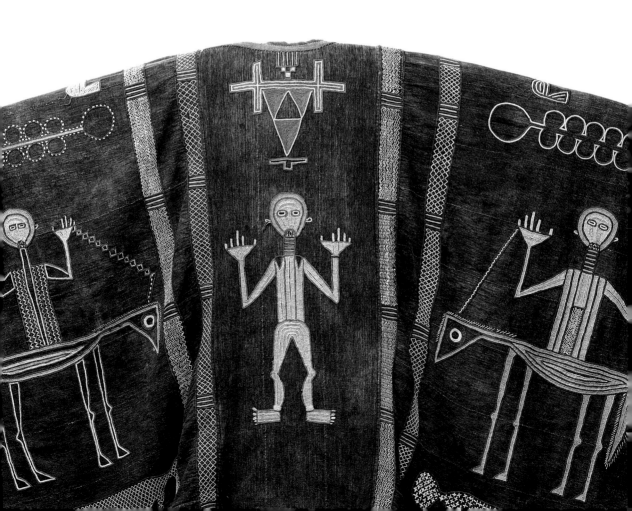

Container (*nembandi*), 1890s
In or near the Mangbetu kingdom, Democratic Republic of the Congo

Bark box containers were traditionally intended to hold the jewelry and hairpins of wealthy Mangbetu women. The royal court of the Mangbetu, founded in the eighteenth century, commanded significant wealth because of its control of regional trade. Members of the court commissioned refined artwork, including jewelry boxes and harps. This particular box, with its human face and legs, however, was more likely made for the European market than for a Mangbetu noblewoman. Jewelry boxes for the court often included geometric motifs, with bases that imitated the shape of a woman's stool, but European colonial officials preferred anthropomorphic sculptures to abstract designs. By the later nineteenth century, artists increasingly made decorative arts in anthropomorphic forms for foreigners, capitalizing on the European market for African art and material culture in this period; Mangbetu kings even commissioned this style of box as a diplomatic gift.

This box was once owned by the Umlauff family in Hamburg. Johann Friedrich Gustav Umlauff (1833–1889) was a ship's carpenter who later bought a bathhouse on the Hamburg coast, selling foreign curios from his sailing connections on the side. He later married the sister of Carl Hagenbeck, an entrepreneur who imported zoo animals from Africa and eventually branched out into organizing horrific "human zoos" as well. Through Hagenbeck's international contacts, Umlauff founded a prosperous business dealing in art and ethnographic objects from Africa. This network of businesses all profited from a European interest in seeing the exotic "other," and from a racist assumption that African rulers, citizens, and artists were less evolved than their European peers.

This piece would have been particularly attractive to European buyers because of the head on the lid. Europeans were impressed by Mangbetu art and architecture, but also fascinated by noble mothers' practice of tightly swaddling infants' heads to create a high forehead, a permanent marker of social status. The elegant brow of this figure would have reminded its European owner of the graceful appearance of courtiers in the royal sphere. Postcards of Mangbetu courtiers and children were popular in the period for the same reason.

Wood, bark, and vegetable fiber
H. 39.4 cm (15½ in.)
Gift of William E. and Bertha L. Teel 1992.408

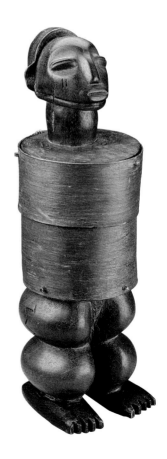

Female figure, 1950s
Possibly near Korhogo, Côte d'Ivoire

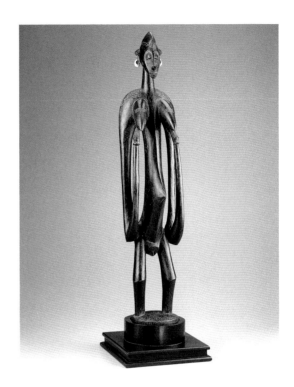

This slender, composed female figure reflects an artist's break with tradition in a changing market. The abstracted face and ornamented body present an iconic beauty, while the fashionable hairstyle dates to the 1930s–50s. The sculptor has punctuated the lines of the body with cascading forms—the sharply pointed chin is echoed in the breasts, stomach, and knees. This masterful abstraction is a hallmark of early-twentieth-century sculpture in northern Côte d'Ivoire, but the thin, curving arms that support the woman's breasts are an unusual gesture. In profile, the woman's arms amplify the curvature of her hips; from the front, they emphasize the delicate dimensions of her waist.

In the 1950s, artists in Côte d'Ivoire faced changing demands in the art market. Sculptures like this one—rhythm pounders used to strike the earth during processions, previously commissioned by men's societies that trained youths and celebrated major community events—were abandoned in some areas in response to a new religious movement from Mali. International interest, always a part of the art market, increased as art dealers began exporting sculpture for clients in Europe and the United States. It is unclear whether the artist who created this sculpture was inspired by his own imagination or sought to attract international patrons through his inventive design. Purchased by Helene Kamer (now Leloup) and her husband between 1958 and 1962 from a Mr. Coulibaly, an art dealer in Abidjan whose first name the Kamers did not record, the sculpture was likely made for an international market. If the sculptor were in contact with dealers like Coulibaly, he may have had a chance to see art from other cultures in West Africa. It is possible that he was looking at Yoruba art from Nigeria, for example, where women are commonly depicted with hands to their breasts in a gesture of welcome or nurturing. The sculpture was included in the first show in the United States to feature Senufo art, held at the Museum of Primitive Art in New York in 1963. As part of the exhibition, the sculpture became an ambassador of Senufo aesthetics, its interpretation changing as it changed location.

Wood and shell
H. 88.9 cm (35 in.)
Gift of William E. and Bertha L. Teel 1996.390

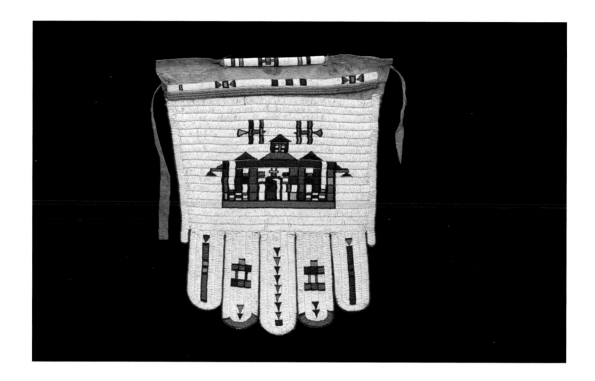

Women's front skirt (*jocolo*), about 1960s
Msiza village, Odi district, South Africa

Glass beads, leather, and brass
L. 71.1 cm (28 in.), w. 62.9 cm (24¾ in.)
Museum purchase with funds donated by Alan and Suzanne
Dworsky, Jeremy and Hannelore Grantham, Hy and Shirley
Zaret Acquisition Fund for African Art, Art of Africa and
Oceania, and Lucy Scarborough Conant Fund 2018.76

Women's ceremonial blanket (*urara*), about
1940s–1960s
Likely Mpumalanga province, South Africa

Glass beads, woolen blanket, bells
L. 170.8 cm (67¼ in.), w. 168.9 cm (66½ in.)
Museum purchase with funds donated by Alan and Suzanne
Dworsky, Jeremy and Hannelore Grantham, Hy and Shirley
Zaret Acquisition Fund for African Art, Art of Africa and
Oceania, and Lucy Scarborough Conant Fund 2018.59

This heavily beaded skirt and blanket reflect
changing styles in amaNdebele fashion over the
twentieth century. Glass beads imported from Europe
and Asia became available in South Africa in the late
eighteenth century, and their rarity ensured that only
the wealthiest of women could sparingly ornament
their clothing with beads. By the twentieth century,
beads were cheaper and more plentiful, and clothing
styles incorporated them in much greater quantities.
AmaNdebele women had previously beaded their
clothing and painted their houses with patterns, but
in the 1960s they used larger, more colorful patterns
to announce their pride in their heritage and identity.
During this period, the apartheid government forced
black residents off their property and into artificially
created "ethnic homelands" with few resources, but
refused to recognize the amaNdebele as a distinct
ethnicity. Alone among other groups in South Africa,
the amaNdebele campaigned for an ethnic homeland

as a way of reuniting their people, who had lost their kingdom and been forced into indentured servitude across South Africa after a brutal war with Boer farmers in 1882.

This skirt—made by a woman living in Msiza village, where families were forcibly resettled in 1953—bears witness to the dislocations of amaNdebele people since the nineteenth century. The skirt is also a testament to the ways that amaNdebele women broadcasted their historic culture while simultaneously asserting their modern identities. The motif—two airplanes over a multistory house with streetlights on either side—speaks to the owner's cosmopolitanism and hopes for the future, while the rare pink beads and three rows of copper rings display her wealth. Only a married woman may wear a skirt with five rounded flaps at the bottom, and the two tiny flaps on either side indicate that this skirt belonged to an established matron who was beyond her childbearing years.

This heavily beaded woolen blanket was similarly worn by a well-to-do older woman. The blanket itself was made by a factory in Middleburg and dates to the 1940s; the bead colors were chosen to match the stripes of the blanket. The beaded panels are a mix of sections from the same period and newer sections added later to repair breakage and update the fashion of the original garment. The snaking pattern on either side is called "ox-cart brake," while the pattern in the center is a riff on the letter K, chosen to prove the beader's skill in creating difficult angular patterns in the final design. While women once wore beaded clothing as part of their everyday clothes, by the 1940s the heavy beaded blanket and finely finished skirt were always considered "best dress."

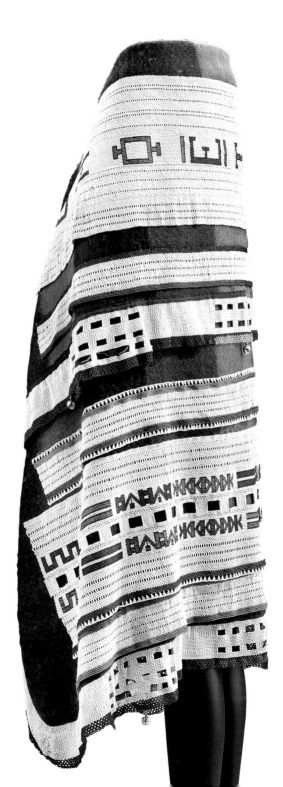

Untitled (*Man Holding Baby*), 1949–51, printed 1996
Seydou Keïta (1923–2001, Malian)

Photograph, gelatin silver print
L. 60.7 cm (23⅞ in.), w. 50.7 cm
(20 in.)
Horace W. Goldsmith Foundation
Fund for Photography
2000.1006

Untitled (*Two Women*), 1958, printed 1997
Seydou Keïta (1923–2001, Malian)

Photograph, gelatin silver print
L. 60.9 cm (24 in.), w. 50.8 cm (20 in.)
Horace W. Goldsmith Foundation
Fund for Photography
2000.1005

Seydou Keïta is the most celebrated African portrait photographer of the twentieth century. Working in the courtyard behind his house, Keïta captured the emerging middle and upper class in Mali with striking immediacy. The stunning use of pattern and texture in his photographs, in his clients' clothing as well as in the bedspreads he used as backdrops, flattens space and emphasizes the sitter's face and gaze. In each of these two photographs, Keïta has captured two sitters whose relationship to each other is unknown. Is the smiling man holding the baby a father, grandfather, or uncle? The gleam of pride in his joyful expression suggests a family connection, as does the easy way he holds the happy child. The man's generous tunic makes him appear larger than life, and the baby further exaggerates the impression of a successful family man. The two women are harder to discern. Are they sisters? Co-wives? Friends? They wear clothing in an identical pattern and similar cut. They share a reserved expression appropriate to dignified, well-to-do matrons. The woman on the left wears her hair wrapper in a classic style, while the woman on the right allows hers to fall past her shoulders, its pattern merging with the backdrop.

1958 Seydou Keïta 1994

Soiree Babenco Club, 1960s
Malick Sidibé (born in 1935 or 1936, Malian)

If Seydou Keïta is the celebrated auteur of midcentury Malian photography, Malick Sidibé is the next generation's chronicler. Shooting with a Kodak Brownie Flash, Sidibé took portraits in the studio but also ventured abroad to parties and beach outings. This photograph was taken in the midst of a house party. Young men and women are dancing together, possibly to the latest James Brown or Rolling Stones record. The scene seems innocent enough, but mixed company in the evening was not socially acceptable in Mali in the 1960s. After the upheaval of the independence era, when Mali secured its freedom from France, an older generation worried that international youth culture was destroying traditional values and tempting young people away from their roots. This generational clash was more than a disagreement about music and sexual mores; the Malian government considered "untraditional" clothing and hobbies dangers to national unity. In the 1960s, the government created a militia responsible for enforcing socialist ideas that included abolishing traditional leadership positions while simultaneously championing markers of traditional culture. Youth caught wearing miniskirts, tight clothing, bell-bottoms, or Afros, or those seen breaking curfew, were sent to reeducation camps. The young people in this photograph are dancing despite the danger, flouting government efforts to stamp out trends that were seen as foreign and therefore reminiscent of the colonizers.

Photograph, gelatin silver print
L. 29.5 cm (11⅝ in.), w. 21.6 cm (8½ in.)
The Lane Collection

Mpumi Moeti, Kwanele South, Katlehong, Johannesburg, 2012
Zanele Muholi (born in 1972, South African)

The South African photographer Zanele Muholi documents her community through intimate portraits, raising awareness of the discrimination that black people and LGBQTIA+ citizens still encounter in South Africa. In a monograph on her portraiture project *Faces and Phases 2006–14*, the artist wrote, "Often even before the organizing starts, merely existing and living is the ultimate beginning of political consciousness, an act of resistance and transgression." Mpumi Moeti, the subject of this portrait, gazes out at the viewer, head tilted, with an expression that combines strength and wariness. One shoulder has fallen forward, creating a secure and seemingly nonchalant stance, the pose causing a ripple in the lines of the shirt. The curves of Moeti's face are suspended between the rectilinear pattern of the plaid and the accentuating black backdrop.

Under apartheid, South Africans citizens were registered according to judgments of their race, and were required to carry identity documents with photographic portraits. Those deemed non-white had few legal rights, and found their movements restricted. Although LGBQTIA+ rights were enshrined in the constitution when apartheid ended in 1994, LGBQTIA+ people in South Africa continue to encounter oppression and even physical violence. Mpumi Moeti did not contribute an essay to Muholi's *Faces and Phases* publication, in which the photograph was included, but her direct gaze insists on the dignity of her personhood, beyond the biases and prejudice that surround ideas of race, sexuality, and gender. "Every individual in my photographs has her own or his own story to tell,"

Muholi said in a 2013 interview with Bim Adewunmi for *New Statesman*. "But sadly we come from spaces in which most black people never had that opportunity."

Photograph, gelatin silver print
L. 76.5 cm (30⅛ in.), w. 50.5 cm (19⅞ in.)
Museum purchase with funds donated by Leslie and Sandra Nanberg 2013.1666

Converging Territories #29, 2004
Lalla Assia Essaydi (born in 1956, Moroccan)

The woman in this photograph stands facing away from the camera. She is entirely covered, except for her left foot, which peeks out below the hem of her wrap. Text flows over both the figure of the woman and the background, filling the image. The woman herself is barely visible, hidden from the viewer's gaze by her garment and the all-encompassing calligraphy; the text in places is so dense that it is illegible.

According to the artist, Lalla Assia Essaydi, "The presence of text is related to the dominance of the word in Islam. . . . Our religion is based on the book, and so everything is based on the word." Islamic calligraphy is a sacred—and typically male—art form. Here Essaydi associates the text with women's bodies to suggest the complexity of gender roles within Islamic culture. She sees her work as a response to the exoticized European image of the harem found in nineteenth-century Orientalist paintings, which often featured women in a state of undress. She also confronts the restrictions that were placed on her and her sisters and female cousins growing up in Morocco. Essaydi's work simultaneously challenges male fantasies of the harem and male prerogatives over women's behavior while also celebrating her cultural identity.

Photograph, chromogenic print
L. 152.4 cm (60 in.), w. 121.9 cm (48 in.)
Horace W. Goldsmith Foundation Fund for Photography 2005.300

Black River, 2009
El Anatsui (born in 1944, Ghanaian, active in Nigeria)

El Anatsui is a professor at the Nsukka campus
of the University of Nigeria, an institution known
for challenging British colonial art instruction
and developing a contemporary aesthetic rooted
in Nigerian art history. Although he was born in
Ghana, Anatsui has taught at Nsukka since 1975.
In his artistic practice, Anatsui challenges himself
to use only locally available materials. Here he has
sculpted discarded liquor-bottle caps and wrappers
into a metallic tapestry, its rolling hills and valleys
recalling a topographical map. At the center, a black
river seems to seep across a border and may refer-
ence disputes over oil wealth and pollution along
the Niger River in southeastern Nigeria. Anatsui's
sculptures challenge consumption and its relation-
ship to environmental degradation.

Despite its beautiful, shimmering surface the
sculpture invokes a history of violence as well as
modern ills. Liquor wrappers with names like "Dark
Sailor" and "Black Gold" hint at Africa's long history
of enslavement and colonial occupation. In keeping
with the innovations of the Nsukka school, the piece
connects to West African aesthetics in new media
and for a new purpose. The blocks of red, black, and
yellow stripes at the lower right resemble woven
kente cloth from Ghana, a historic Akan tradition
that was reinvigorated as a national emblem after
Ghana rejected colonial rule in 1957.

Aluminum, bottle caps, and copper wire
L. 266.7 cm (105 in.), w. 355.6 cm (140 in.)
Towles Fund for Contemporary Art, Robert L. Beal, Enid
L. Beal and Bruce A. Beal Acquisition Fund, Henry and
Lois Foster Contemporary Purchase Fund, Frank B. Bemis
Fund, and funds donated by the Vance Wall Foundation
2010.586

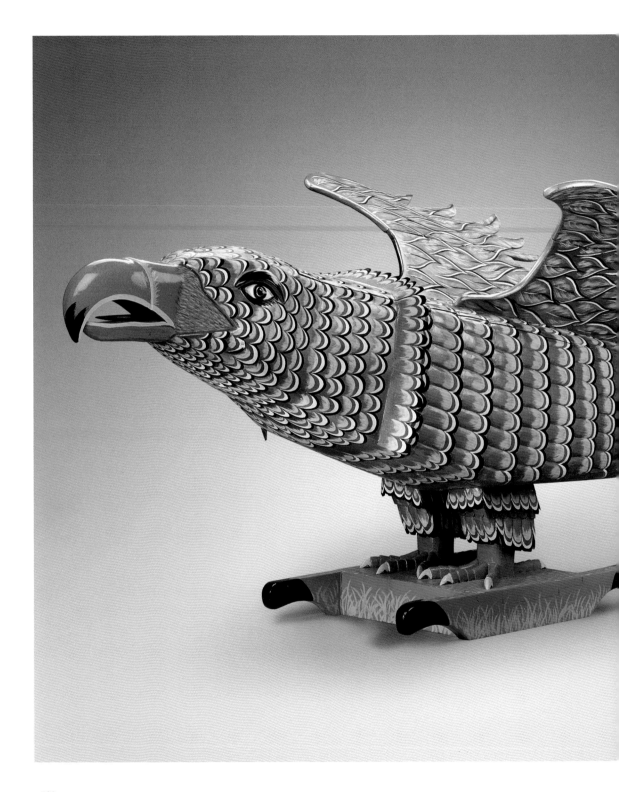

Fantasy coffin (*abebui adera*) in the form of an eagle, 2017
Joseph Tetteh-Ashong (known as Paa Joe, Ghanaian, born in 1947)

Joseph Tetteh-Ashong, best known as Paa Joe, created this coffin in the shape of an eagle with wings outstretched for the MFA collection. He belongs to the second generation of artists making so-called fantasy coffins for wealthy families, in forms that evoke the life of the deceased—such as a tomato for a tomato farmer, a chicken with many chicks for a mother of a large family, or a Mercedes car for a businessman. Paa Joe trained with his uncle, Seth Kane Kwei (born 1925–30, died 1992), a celebrated practitioner of the form, and opened up his own workshop in 1976. He began exhibiting his work in art museums in 1989 while continuing his coffin business in Accra.

The eagle is meaningful to two different sets of contemporary patrons. The powerful creature has long been a symbol of chiefly authority among the Ga, a community that settled on the Accra coast in the sixteenth century and are celebrated fishermen and boat-builders today. Figurative coffins likely developed out of lion-shaped palanquins that held Ga chiefs aloft during special events, a form first used in Accra in the 1930s. The eagle is also meaningful for Christians, due to its association with St. John; beginning in the 19th century, many Ghanaians converted to Christianity. Church burial grounds often insist that believers be buried in a simple coffin, but will sometimes allow a coffin in the shape of a Bible or an eagle.

This coffin was intended for display. The eagle is shaped and painted like a coffin made for burial, but it is crafted out of harder and more durable wood to assure its longevity above ground. The MFA chose the eagle motif because it is as recognizable to an American visitor as to a Ghanaian audience—as a motif conveying leadership and excellence, as well as a common symbol on Christian pulpits throughout the city of Boston. The eagle is also one of Paa Joe's best-known forms, and includes the finely worked curves and detailed painting that are hallmarks of his sculptures.

Wood
Overall (with wings folded): H. 132.1 cm (52 in.), w. 91.4 cm (36 in.), d. 287 cm (113 in.)
Museum purchase with funds donated by Deborah Glasser 2017.4436

Further Reading

Given the geographic area and time period covered by this book, a detailed bibliography would include references in many languages and many that may not be available to the general reader. Therefore, this abbreviated list comprises English-language books that cover broad areas, time periods, or subjects, and can be found in general libraries. The bibliographies of these books will point the reader to more specific information on individual artists or traditions. The recent Visions of Africa series published by 5 Continents Editions is also a useful starting point for individual African kingdoms and cultural groups; these books provide the most up-to-date bibliographies on their specific subject areas.

Atil, E. *Renaissance of Islam: Art of the Mamluks.* Washington, D.C.: Smithsonian Institution Press, 1981.

Berzock, Kathleen Bickford. *For Hearth and Altar: African ceramics from the Keith Achepohl Collection.* Chicago: Art Institute of Chicago and Yale University Press, 2005.

Ekpo, Eyo. *Two Thousand Years: Nigerian Art.* Lagos: Federal Department of Antiquities, 1997.

Enwezor, Okwui, Oliu Oguibe, and Octavio Zaya. I*n/Sight: African Photographers, 1940 to the Present.* New York: Solomon R. Guggenheim Museum, 1996.

Enwezor, Okwui. *The Short Century: Independence and Liberation Movements in Africa, 1945 – 1994.* Munich: Prestel, 2001.

Gardi, Bernhard, and Kerstin Bauer. *Woven Beauty: The Art of West African Textiles.* Basel: Museum der Kulturen, Basel, 2009.

Kasfir, Sidney Littlefield. "One Tribe, One Style." *History in Africa,* 11 (1984):163–93.

Mudimbe, V.Y. *The Idea of Africa.* Bloomington: Indiana University Press, 1994.

Njami, Simon. *Africa Remix: Contemporary Art of a Continent.* London: Hayward Gallery Publishing and Hatje Cantz Verlag, 2005.

Perani, Judith, and Norma Hackleman Wolff. *Cloth, Dress, and Art Patronage in Africa.* New York: Berg, 1999.

Phillips, Tom. *Africa: The Art of a Continent.* New York: Prestel, 1995.

Visona, Monica Blackmun. *A History of Art in Africa.* Upper Saddle River, N.J.: Prentice Hall, 2008.

Weinstein, Laura. *Ink, Silk & Gold: Islamic Art from the Museum of Fine Arts, Boston.* Boston: MFA Publications, Museum of Fine Arts, Boston, 2015.

Figure Illustrations

Credits

1
Relief plaque showing two officials with raised swords, c, 1530–1570
Benin Royal Bronze Guild
(Igun Eronmwon; founded 12th–13th century, Benin kingdom, Nigeria)
Copper alloy
H. 43.2 cm (17 in.), w. 31.8 cm (12½ in.)
Robert Owen Lehman Collection
2018.223

2
Female figure
Democratic Republic of Congo, late 19th century
Wood, skin, hair
H. 46 cm (18⅛ in.)
The British Museum
As published in The Burlington Magazine, vol. XXXVI, no. CCV (205), 1920

3
Female figure
Democratic Republic of Congo, late 19th century
Wood, skin, hair
H. 46 cm (18⅛ in.)
The British Museum

4
Eliot Elisofon
Minganji masqueraders, near Gungu, Congo (Democratic Republic), 1970
Photograph

5
Two Palace Posts, about 1880–1930
Obembe Alaye (Yoruba/Nigerian, about 1869–1939)
Nigeria, Eikti region, palace of Efon-Alaye
Wood, pigment
H. 207.01 cm (81½ in.)
Gift of William E. and Bertha L. Teel
1996.387, 1996.388

6
Power figure (nkishi)
Southeastern Democratic Republic of the Congo, 20th century
Wood, metal, fiber, leather, beads, skin
H. 60.96 cm (24 in.)
Gift of William E. and Bertha L. Teel
1994.413

7
An altar in Benin City, 1891
Cyril Punch
Photograph
National Museum for African Art

Grateful acknowledgment is made to the copyright holders for permission to reproduce the works as follows.

pp. 128 &129: © Seydou Keïta Estate. Courtesy J.M. Patras

p. 130: © Malick Sibide. Courtesy of the artist and Jack Shainman Gallery, NY.

p. 131: © Zanele Muholi. Courtesy of the artist, Yancey Richardson, New York, and Stevenson Cape Town / Johannesburg.

p. 132: Reproduced with permission

pp. 134–135: Courtesy of the artist and Jack Shainman Gallery, NY

pp. 136–137: Reproduced with permission.

Index